IMAGES
of America

AROUND
WATKINS GLEN

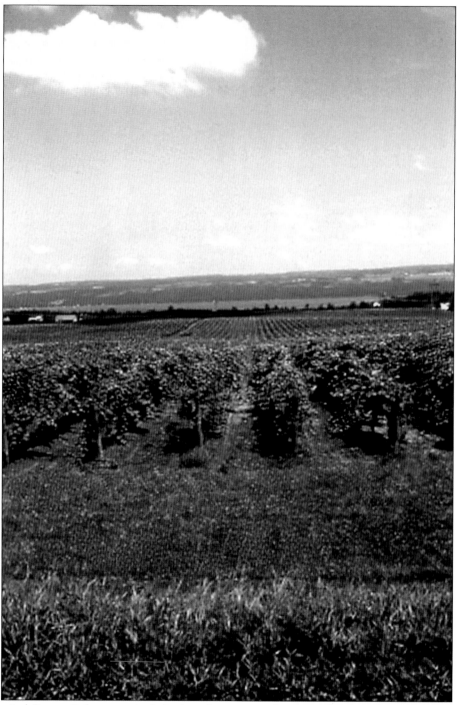

A typical Seneca Lake scene includes broad expanses of water and vineyards on the slopes of both sides of the lake. This view is from the west side.

On the cover: Golfers at Glen Springs had a great view of Seneca Lake. (Schuyler County Historical Society.)

IMAGES
of America

AROUND
WATKINS GLEN

Charles R. Mitchell and Kirk W. House

ARCADIA
PUBLISHING

Published by Arcadia Publishing
Charleston SC, Chicago IL, Portsmouth NH, San Francisco CA

Printed in the United States of America

Library of Congress Catalog Card Number: 2006924314

For all general information contact Arcadia Publishing at:
Telephone 843-853-2070
Fax 843-853-0044
E-mail sales@arcadiapublishing.com
For customer service and orders:
Toll-Free 1-888-313-2665

Visit us on the Internet at http://www.arcadiapublishing.com

CONTENTS

ACKNOWLEDGMENTS

The vast majority of these images came from the Schuyler County Historical Society in Montour Falls. This was possible through the kind permission, and the valued assistance, of museum director John Potter. Also very helpful to us was volunteer Marian Boyce, long-term Dix town clerk and now town historian of Dix. For those interested in Schuyler County's olden days, or in local genealogy, we recommend a visit to the society's Brick Tavern Museum in Montour Falls, with room after room about life "back when."

Since racing is such an integral part of Watkins and Schuyler, we also need to thank Mark Steigerwald (director) and Glenda Gephart (community relations director) at the International Motor Racing Research Center in Watkins Glen for their assistance with racing photographs. Stop in when you are visiting, there is almost always an exotic racer in the lobby.

Dr. Tom Cornell, professor at Rochester Institute of Technology, and earnest student of his grandparents' world in the Southern Tier and southern Finger Lakes, immediately lent two albums left by his grandfather, George Cornell, photographically recording a long-ago visit to Watkins Glen. These images are marked accordingly, and for all the images, and all the help, we again express our thanks.

INTRODUCTION

Schuyler County: The First 150 Years tells the tale of George Taylor, who lived in Monroe County for a year, then spent 43 years in Tioga County and 18 in Chemung before finishing his days in Schuyler—without once changing his residence in the village of Havana.

Such was life in western New York between the Revolution and the Civil War, as populations and political fortunes rose, fell, and shifted. Like many western and central counties, Schuyler (established in 1854) is named for a hero of the Revolution. Again like those counties, Schuyler is a hilly, deeply-gouged lakeside region, showing the beautiful ravages of the last glaciation.

We both enjoy visiting Watkins Glen and Schuyler County, and we have both enjoyed our photographic romp among these towns, villages, glens, farms, and people. We hope you will enjoy it too.

One

A PEEK IN THE ALBUM

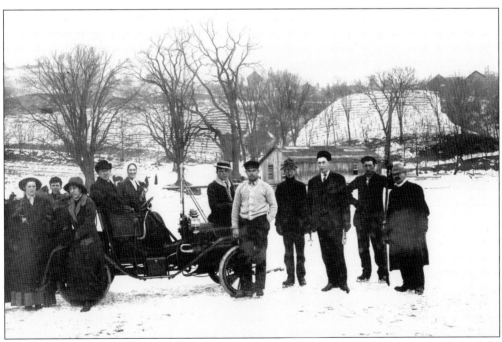

Places are great, but people, animals, and gatherings are what strikes the heart when one carefully turns the pages of a brittle old album. The faces, the bad times, the happy times—these make one stop and realize that ancestors, although they may have worn funny clothes, were quite the same as people today. This pioneering couple in Valois, for instance, attracted quite a crowd, and a century later, the car would still draw spectators out into the cold (or in from ice-skating).

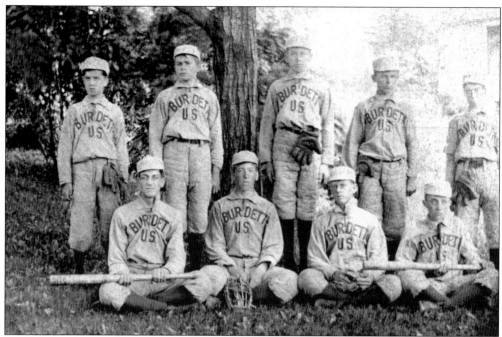

Baseball has always touched America's heart, but those old uniforms elicit a chuckle. Take a look at the glove hanging from the belt of the player standing third from left.

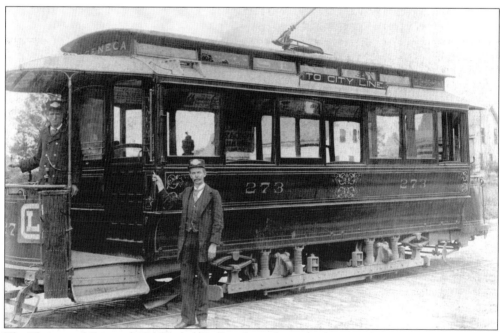

The Elmira and Seneca Lake Electric Railroad ran from Watkins to Elmira between 1900 and 1923. Charles Sherwood Frost, who later pressed the state to take over the glen, helped organize the line, but that got him no consideration. In 1906, he ran for the trolley in the cold, overheated himself, developed typhoid pneumonia, and died.

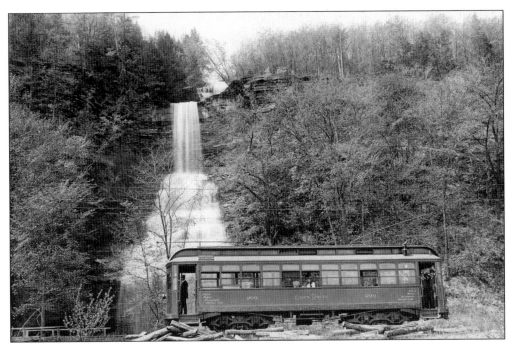

Riders got a much better view than they would on most other lines.

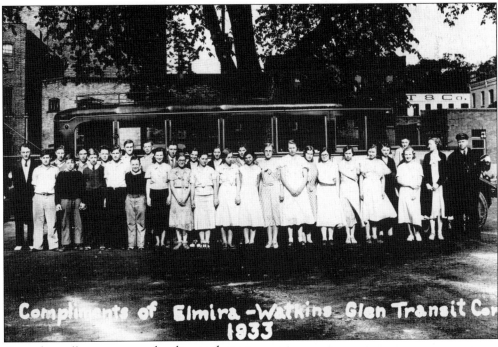

Compliments of Elmira - Watkins Glen Transit Co.
1933

Once the trolley was gone, a bus line took over.

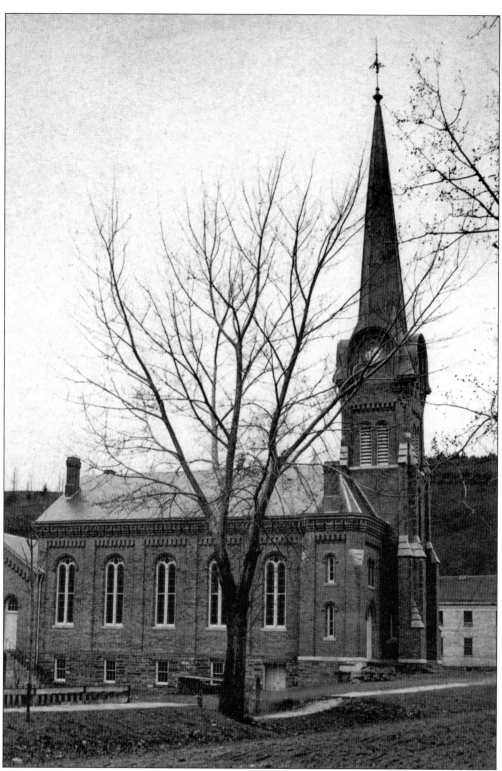

The Baptist church in Montour Falls displays a controlled exuberance.

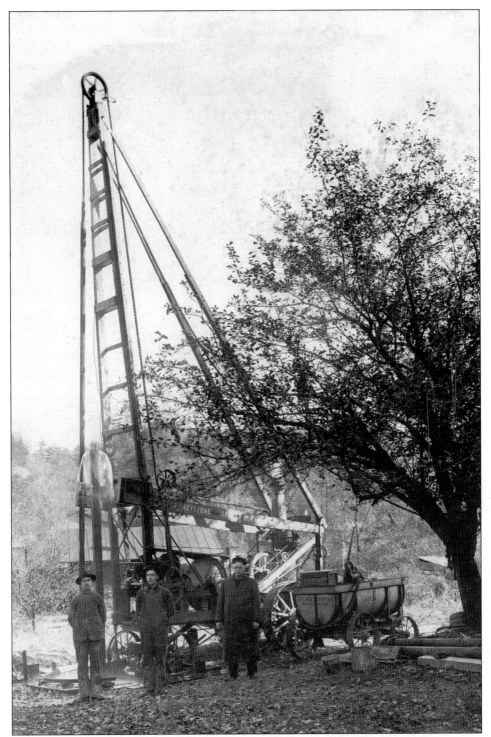

Drilling for salt lent a special flavor to life around Watkins. Until being driven out during the Revolution, the Seneca collected salt in what is now called the Catharine (pronounced KathaREEN) Marsh.

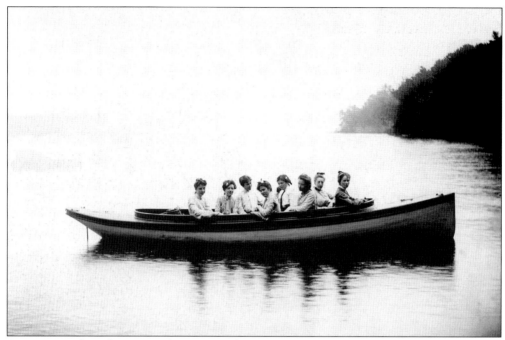

Boating, or at least floating, is always a popular pastime. These young women seem clearly to be without a paddle.

Sulky racing, with trotters or pacers, still survives in the region.

Is business extra good for proprietor G. C. Beebe, or is someone else turning the summersault?

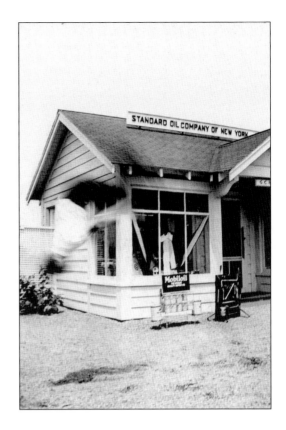

Notice the ankle socks and the grill on the hood. Styles have changed.

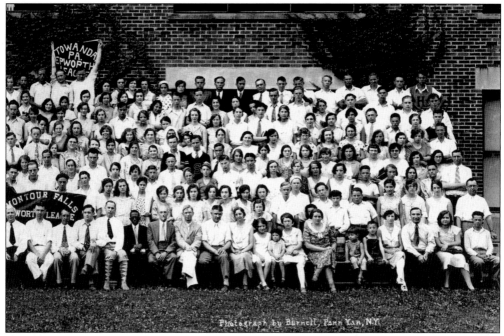

The Methodist Epworth League attended a gathering at Keuka College near Penn Yan. The man seated fifth from left in the front row wears knickers with eye-catching socks. Perhaps the man to his left is the speaker, as he holds a stack of books on his lap.

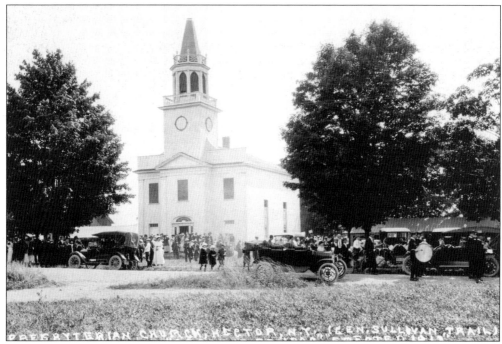

The 1813 Presbyterian Church in Hector is the oldest church structure in the county. Folks here are drifting away from a just-completed Fourth of July oration in 1916.

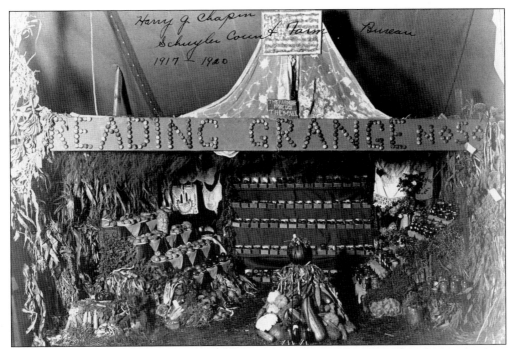

Reading Grange members in the early 20th century enthusiastically display the bounty from their labors. The small sign above the r in "Grange" reads, The farmer needs the mail. Obtaining rural free delivery was a long struggle for the Grange folks, but they finally won.

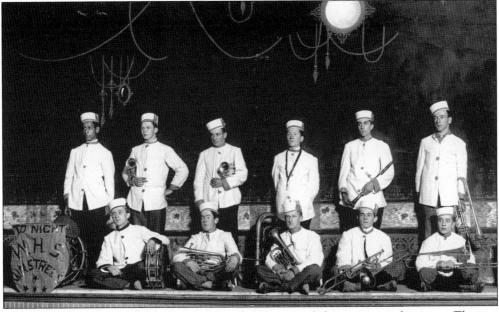

The minstrels' dull expressions suggest that this is a staged shot, not a performance. They no doubt livened up with an audience in view. From left to right are (first row) Willis Gates, ? Gould, Harmon (possibly Norman) Green, John Fordham, and Carl King; (second row) Jessie Patterson, Frank Skinner, Tracy Clawson, Preston Sheldon, Leon Dermott, and "Chub" Skinner. Bill Gates was the leader.

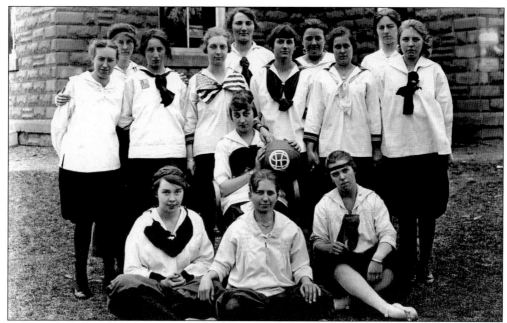

Long before Title IX, Odessa High School (notice the intertwined initials on the ball) fielded women's basketball teams. The 1916 squad was identified as, from left to right, (first row) Hazel Beckwith, Goldie Harris, and Gertie Lund; (second row) Josephine Catlin (holding ball); (third row) unidentified, Eolia Strong, Esther Couch, Marie Snieth, Natalie Ward, and Edith Ganoung; (fourth row) unidentified, Lillie Jonas, Winnie Shelton, and Maude Cooley. This must be a posed picture. Notice the high athletic shoes on Beckwith and Harris, compared with the slippers Lund is wearing.

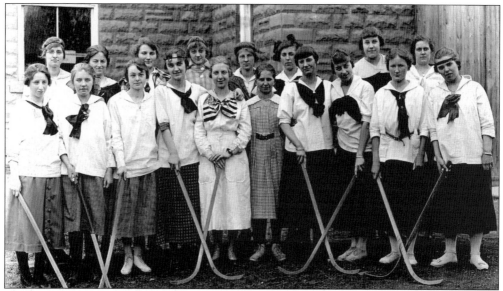

Many of those same basketball players—and the assorted footgear—were also on the field hockey team. Since the heavy coats in the back row do not fit any of the typical patriotic holidays, perhaps these 1916 students with prominent flag decorations were thinking about our approaching entry into the Great War.

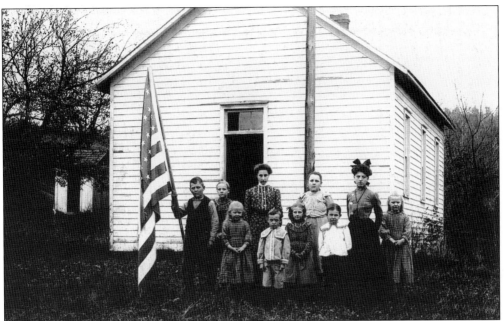

Dale Lee Huff (second from right, with bow) was photographed around 1902 with her scholars at Stone District School on Fitzpatrick Hill. Every school would have its classroom flag, and even its outside flagpole. In addition, the Civil War was close, and the Spanish-American War was only four years past—patriotism was strong. Two blonde girls, slightly different in stature, have identical dresses of the same cloth pattern; presumably they are sisters. Two small boys with extravagant collars may be brothers, and may be fed up with wearing them. Teacher Huff appears not much older than one of her charges (fourth from left). Also, Huff wears something dangling from the yoke around her neck—possibly a watch, since wristwatches were not yet popular. Finally, notice how the door hangs open on the little house to the left—maybe someone is in a hurry. It is amazing what just one photograph reveals when it is studied just a little. Huff would be proud of such careful observation.

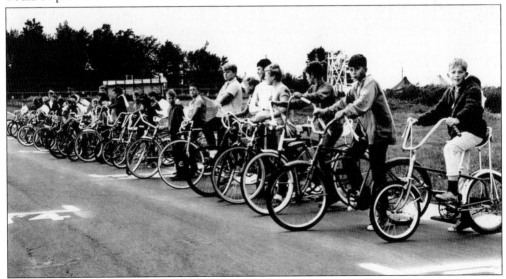

None of the cyclists in this 1967 bike race have the wide collars seen at the Stone District School.

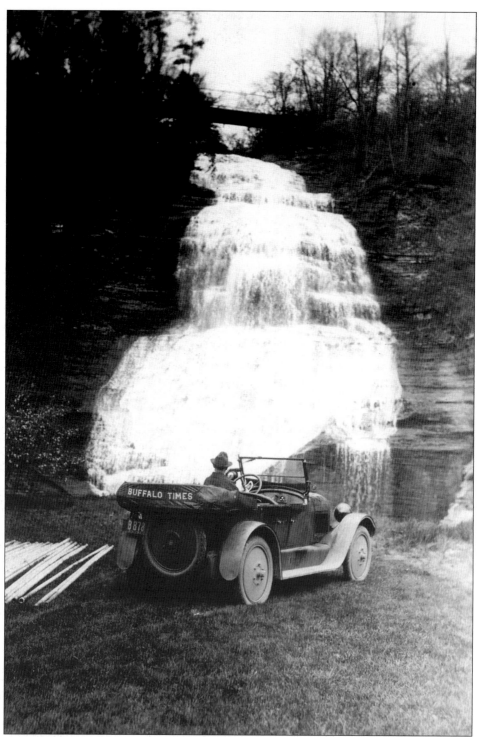

Chequaga Falls, which attracted the *Buffalo Times*, attracted Louis Philippe a century before. The future "bourgeois king" sketched or painted a picture of the falls, said to be in the collection of the Louvre. Chequaga has been variously spelt through the years. Similar falls tumble down nearby.

It is April Fool's Day sometime in the 1960s, and the anglers are out in force for the first day of trout season. Catharine Creek (including Deckertown Falls) is a major trout stream.

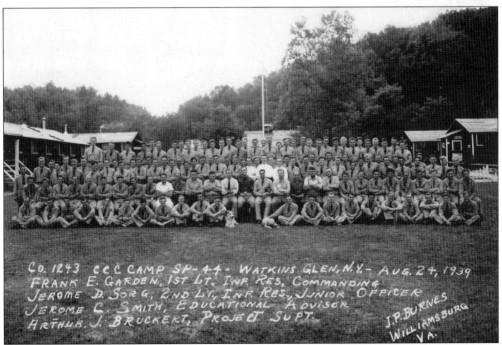

During the New Deal, Civilian Conservation Corps camps operated in Watkins Glen and in Burdett. Two dogs are stretched out in front row center of this 1939 group in Watkins Glen.

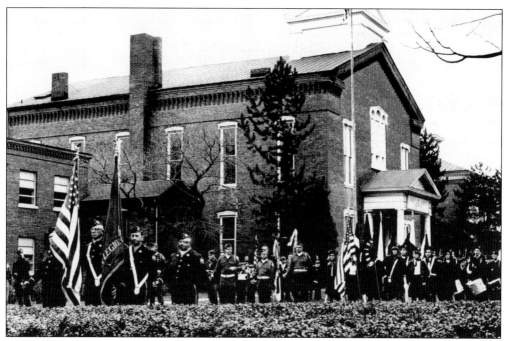

With much of a long, hard century gone, the American Legion, along with other groups, led remembrances for what one generation would know as Armistice Day, another as Veterans Day.

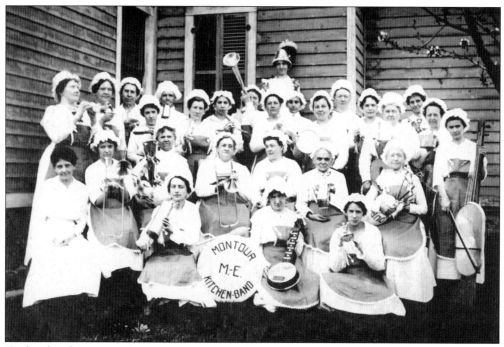

Kitchen bands were popular once upon a time, although this group is concealing their enthusiasm.

A more traditional band helped celebrate the Methodist Sunday school picnic in Reading Center.

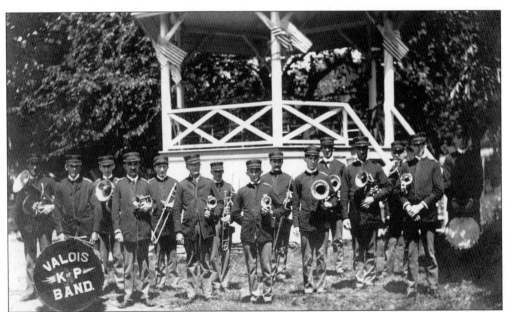

Over in Valois, the Knights of Pythias Band played almost entirely in brass. The Pythians are still around nationwide, but like all fraternal groups faded rapidly through the 20th century and beyond.

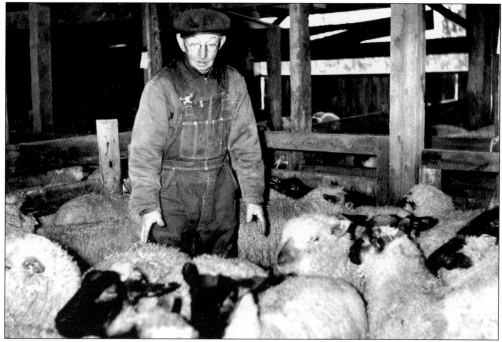

For many years, sheep farming was a big business in Schuyler, with 30,000 animals around 1900. The Watkins Glen Lamb Pool was a key part in the operation.

Sheep and lambs both require a lot of assistance, and Alan Davis of Hector was ready when duty called.

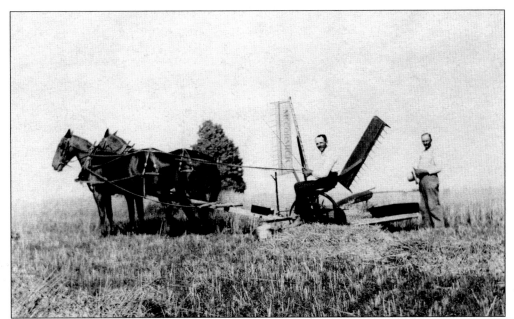

Even with tractors rushing into the field, some horse-drawn farmwork survived in the Finger Lakes until World War II and is now reviving with growing numbers of Amish and conservative Mennonites. Lyman DePew seems perfectly happy with his team and his McCormick equipment in this 1912 picture. Perhaps the older gentleman on the right is Lyman's father—the resemblance is very strong.

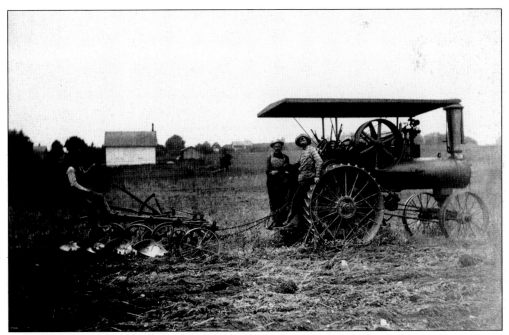

This steam tractor may well predate Lyman DePew's picture, and the equipment being towed with a chain is certainly meant for draft animals.

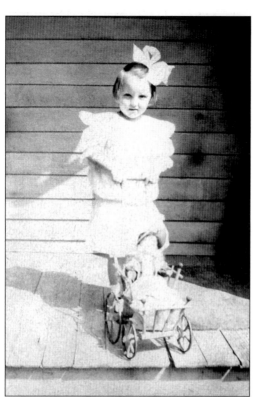

Helen Ayers (later LaMoreaux) proves that dolls and carriages have an enduring appeal.

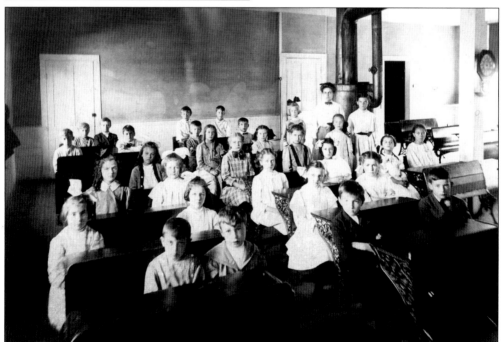

Start at front left, where two little fellows sit at the same desk, go back to the third desk in that row, go one desk to the right, and Helen Ayers is seated on the reader's right. The stove is impressive, but notice that the clock is placed where none of the students may see it.

26

Leona Ayers came from an age when not only furs but feathers were the privilege of every well-off woman.

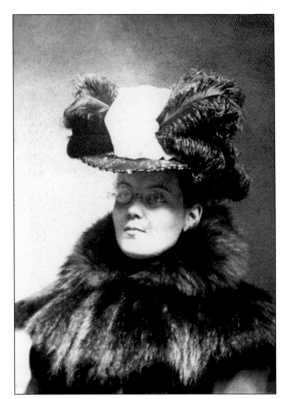

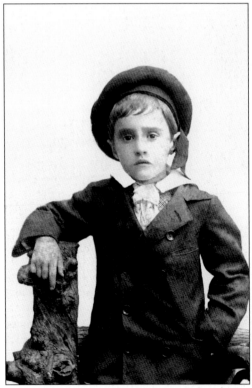

George J. Magee Jr. submitted to photography in 1893. The stump on which he leans is a standard photographer's prop.

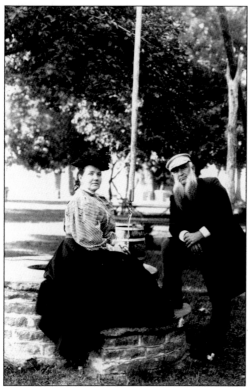

"*O tempora, o mores,*" moaned an unhappy ancient Roman. Mr. and Mrs. Richardson of Valois prove that the times and the manners do indeed change—drastically, in Mr. Richardson's case.

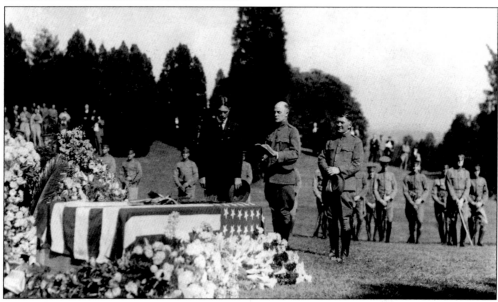

Jane Delano was an energetic leader in the American Red Cross, heading the Home Nursing Service (which she founded), the War Relief Board, and the Red Cross Nursing Service. Almost alone among world leaders she foresaw the Great War and grimly set about preparing for it. Once America entered the conflict, she headed up the Army Nursing Service. Delano died in France five months after the Armistice and was reinterred in Arlington National Cemetery. A measure of her success is the fact that five American Legion posts bear her name.

Two

A WANDER IN WATKINS

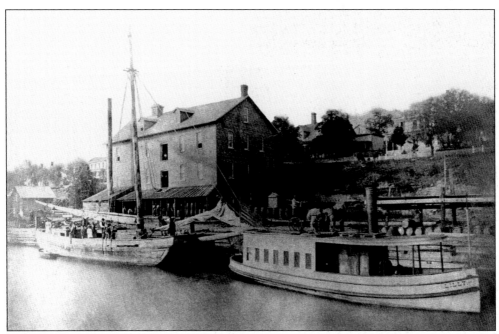

Watkins, later changed to Watkins Glen, lies in the vale at the inlet to Seneca Lake. In the 1830s, the sleepy little village found itself well placed when the Seneca-Cayuga Canal connected those two lakes to the Erie Canal. Money interests in Elmira and Corning built the Chemung Canal to connect the southern tier of New York to Seneca Lake and thereby the Erie Canal. Watkins was then a port with world connections. Steamboats made daily runs to Geneva with various stops along both shores. In the photograph above, around 1885, a sailing scow and the tiny steam-powered *Lilly* are seen tied up at Seneca Lake Brewery. Notice the American flag at *Lilly*'s stern and the horse-drawn dray with kegs.

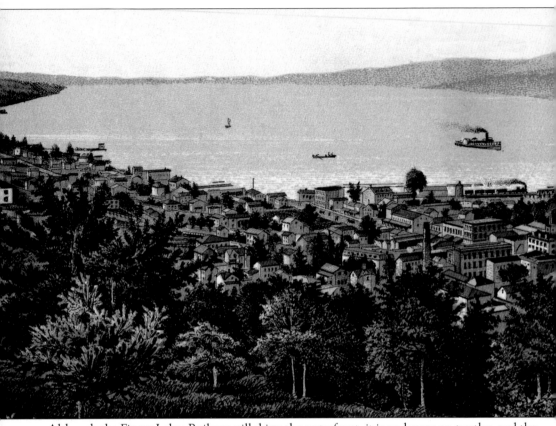

Although the Finger Lakes Railway still skirts the waterfront, it is no longer on trestles, and the waterfront now serves pleasure boats, along with strolling families. Summertime finds festivals such as the Watkins Glen Waterfront Festival, which includes the Cardboard Boat Regatta. Numerous structures are recognizable in this sketch including the Frost Building, Flatiron

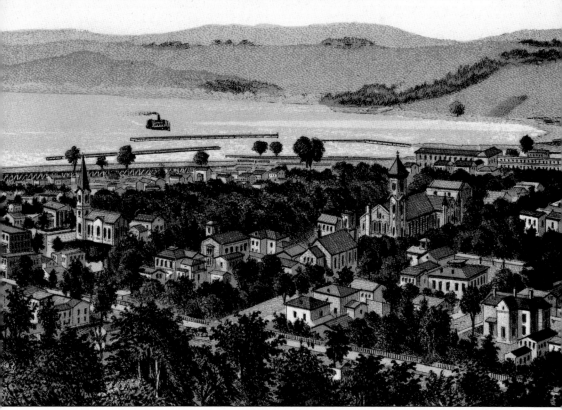

Building, Jefferson Hotel, and several churches. Postcards like the one seen on these two pages were popular in the 1890s. Artists would draw them from photographs taken with the new popular panoramic cameras. Hand tinted by the artist, they were relatively expensive compared to other postcards. These panoramic cards are highly valued by collectors today.

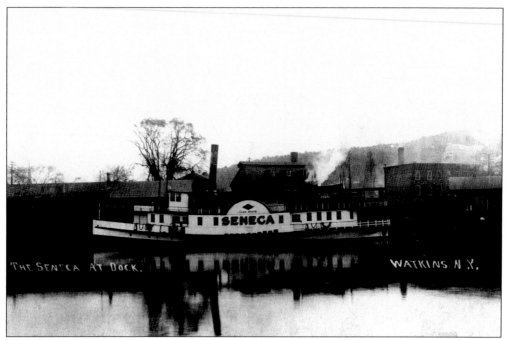

The *Seneca* was a popular steam-powered side-wheeler. Built by William B. Dunning in 1883, it sank in 1909. That is the Frost Building on the right.

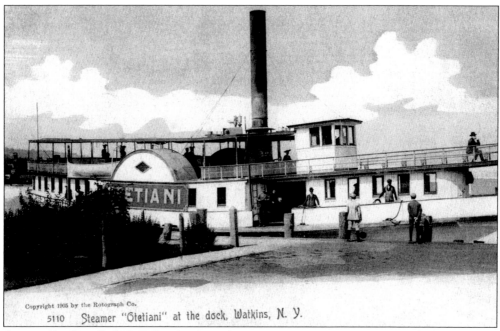

Otetiani (fondly called "O. T.") is fitted to take passengers or excursions. Notice the huge whistle apparatus just aft of the stack and the boys on the seawall with caps, short pants, and knee socks. Also notice *Otetiani*'s similarity to *Seneca*. They are the same vessel, under different names.

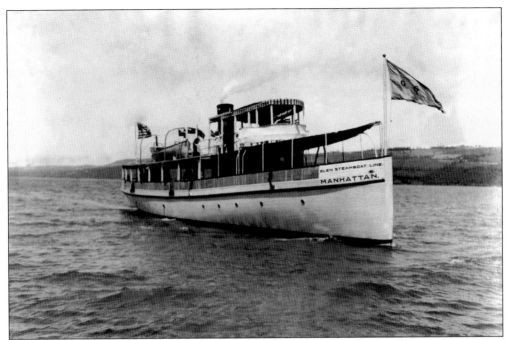

In 1915, *Manhattan* made daily runs between Watkins and Geneva. *Manhattan* later sank in Cayuga Lake.

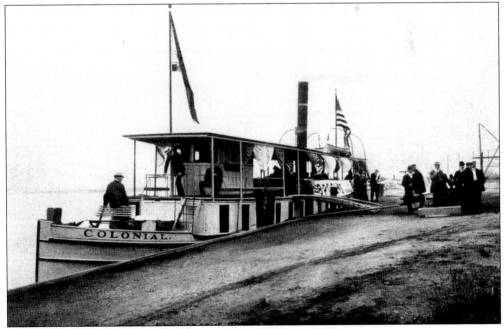

Colonial, at the north end of the lake, is embarking a party of Elks.

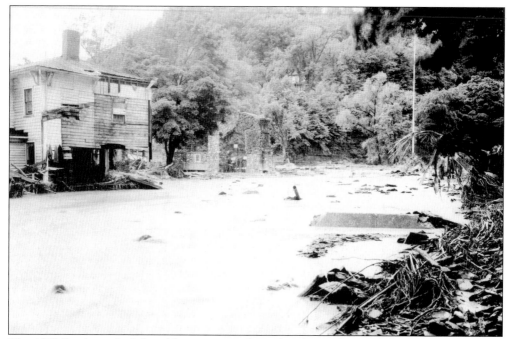

The 1935 flood wrecked the old entrance arch to the glen and moved the house on the left. Mostly, however, the weather behaves itself, and visitors easily find their way around.

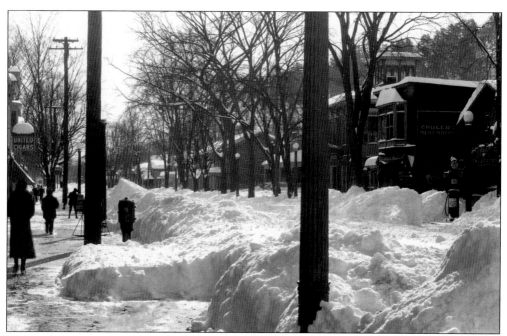

While floods are uncommon, of course it does snow now and then. Notice the wall art advertisement behind the gas pump.

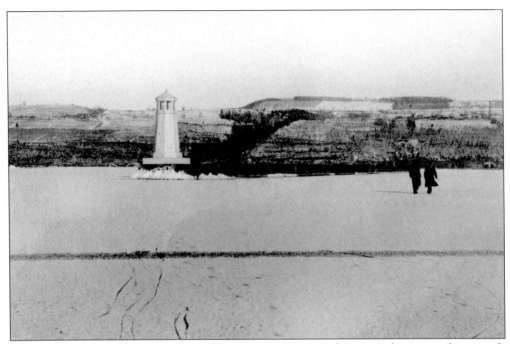

Old tales insist that early motorists used Seneca Lake water in their car radiators, on the grounds that Seneca (36 miles long, and over 600 feet deep in parts) never froze. In fact, it did, once in a while anyhow.

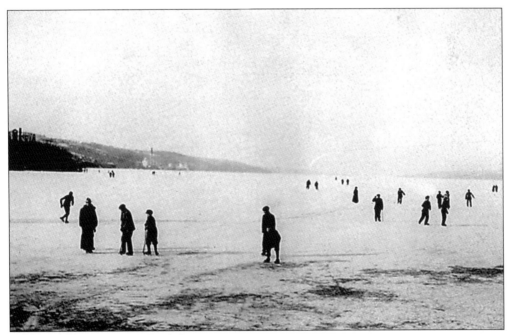

This particular freeze delighted skaters in 1912.

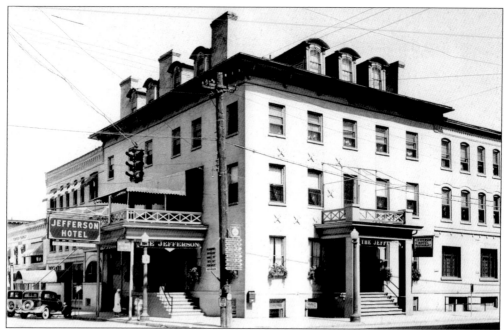

The Jefferson was a proud elegant landmark in Watkins for over 100 years. Directional signs on the left of the pole on Franklin Street (Route 14) point to Penn Yan, Hornell, and Buffalo. On the right (Route 414) are signs to Rochester, Syracuse, Auburn, and (heading the other way) Glen Springs.

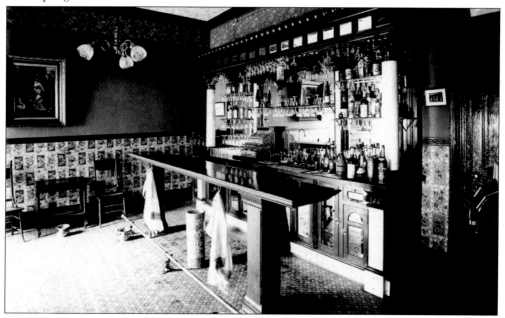

For those who went in for that sort of thing, the Jefferson's bar was the acme of excellence. The floor is intricately designed, the wainscoting tiled. The bar top gleams like a mirror, and towels are graciously hung on the customers' side. Behind the bar is a brass cash register (left) and a knee-high icebox (lower right). The brass rail is steady and sturdy, and all three spittoons are polished to a fare-thee-well.

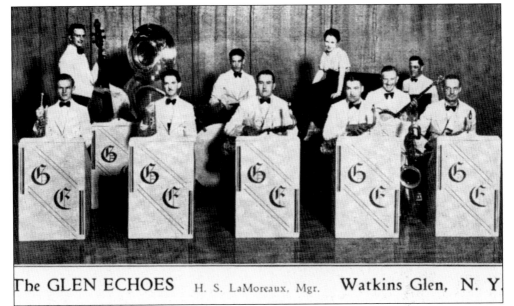

The GLEN ECHOES H. S. LaMoreaux, Mgr. Watkins Glen, N. Y.

There was a time when vivacious visitors and rumbling residents would swing and sway to the trembling tones and lively lyrics of the Glen Echoes orchestra. But those days are, alas, a long time gone.

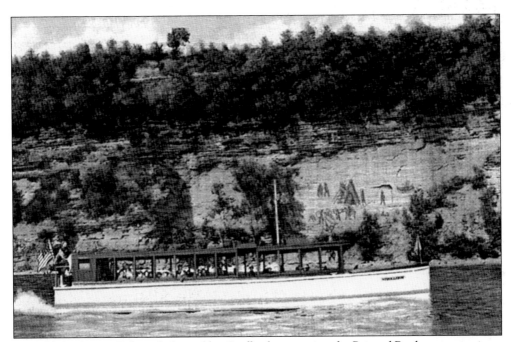

Capt. Philip Burton Palmer dedicated his *Stroller,* here passing the Painted Rocks, to excursions. Palmer launched a series of *Stroller* boats, the first in 1909. The operation descended to the current Captain Bill's outfit.

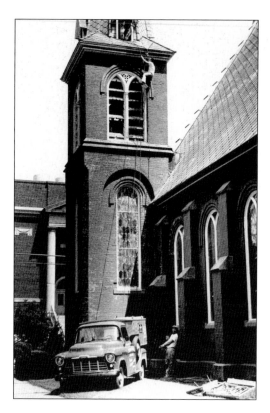

St. Mary's Church (Catholic) had some work done on its steeple, calling forth a pickup truck almost as interesting as the structure itself. The two fellows down at the right do not look like they are doing much, but they are the key to the whole operation. Without them, the fellow suspended twixt earth and heaven would find himself on a short trip to both, simultaneously.

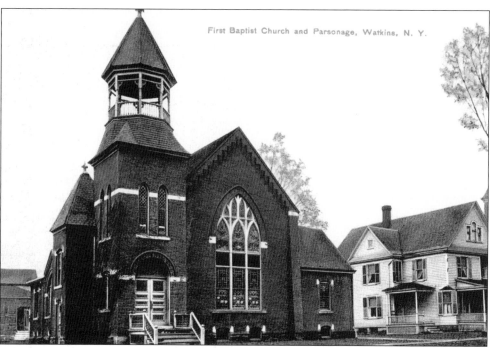

First Baptist Church and Parsonage, Watkins, N. Y.

What games children would have played out in that railed space on the steeple, assuming they could sneak up there.

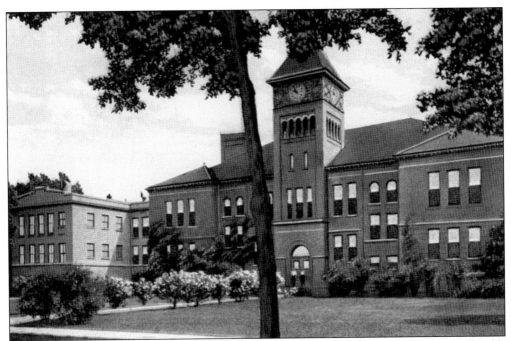

It has had expansion and alteration, but the high school building seen in this postcard still holds its familiar place, although it is now the middle school.

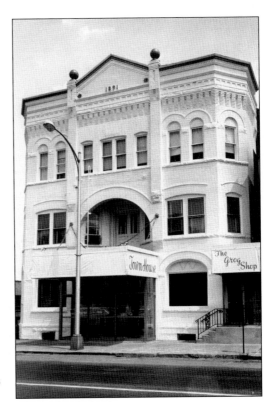

The street level of this lovely 1891 structure is now home to the Watkins House Restaurant.

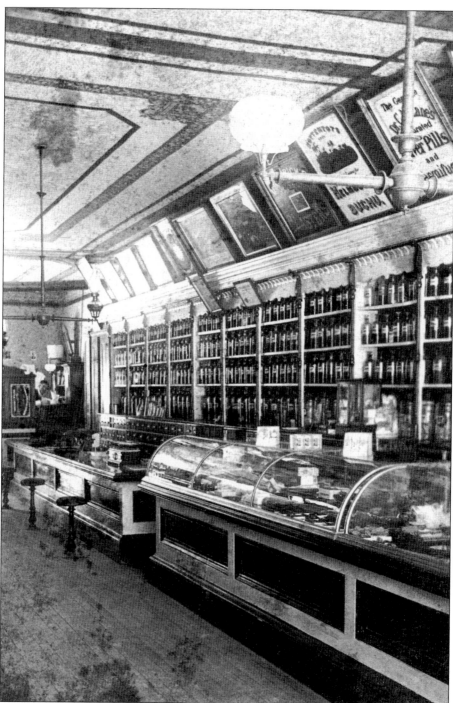

Thompson's City Pharmacy was clearly well stocked. Notice the three stools at the soda fountain. From overhead hang what may be gaslights, possibly converted to electricity. The front set has globes, while the back pair have oil-lamp chimneys. The slanted advertising signs above on the right resemble those done by Claude Jenkins, one lake over in Hammondsport, around the same time. Gates Brothers in Watkins produced this as half of a stereograph set.

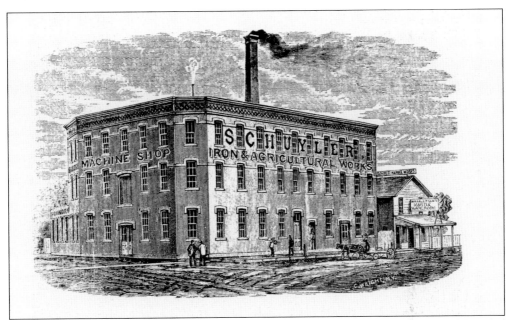

In 1863, Charles Sherwood Frost left the army, moved to Watkins, got married, and founded a marble business (lower right) all in one month. Ten years later, he built the dramatic Frost Building and expanded the business with a foundry, machine shop, iron works, and agricultural machinery and supplies. The brick giant at the lake end of Franklin Street now houses Seneca Harbor Wine Center and the Schuyler County Chamber of Commerce.

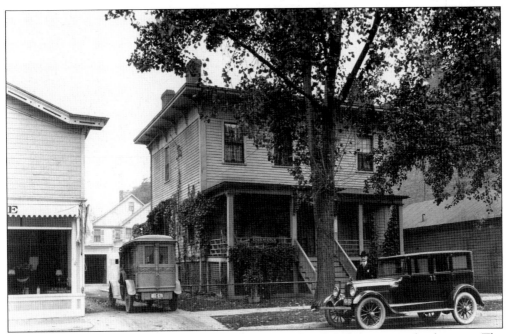

The touring car at the curb gleams, but notice the Charles N. Cole hearse in the driveway. The year is 1922.

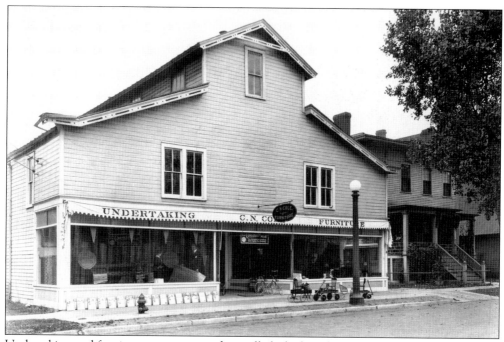

Undertaking and furniture were once traditionally linked, each requiring much woodwork.

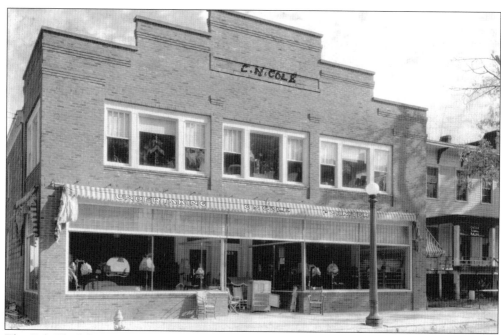

The Cole Block later received a brick facade. Watkins Sporting Goods now has the street level.

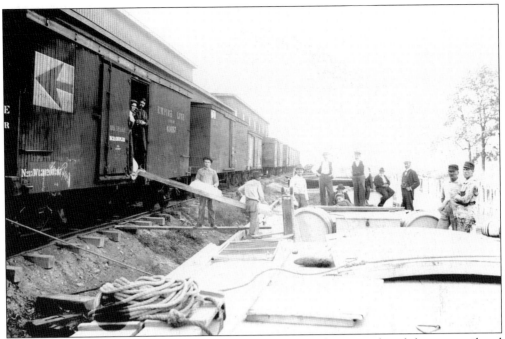

The canal also served Watkins Salt (now Cargill). Here workers transfer salt between railroad and barges.

Three (temporarily) airborne youngsters demonstrate other uses for a fine canal.

Out into the lake, a line of four pleasure craft set out to enjoy the largest of the Finger Lakes.

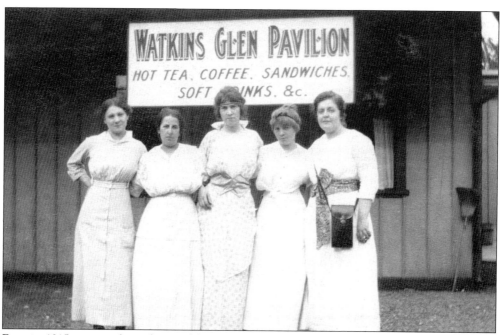

Even in 1915, tourists formed a notable part of the local economy. Notice that the lady on the right end has her Kodak handy.

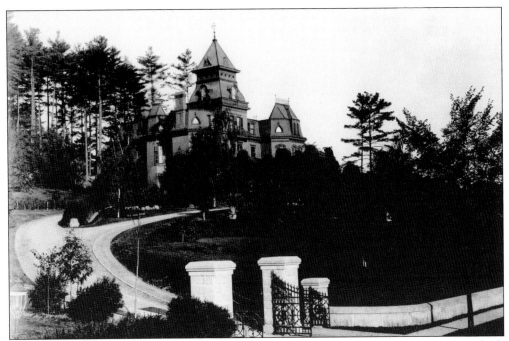

John Magee, whose family had an extensive background in railroads, coal, and Congress, built himself a remarkable mansion in Watkins.

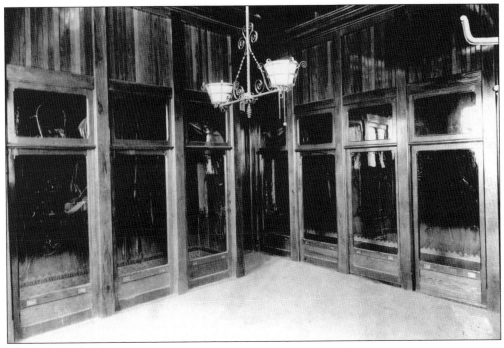

This is his tack room.

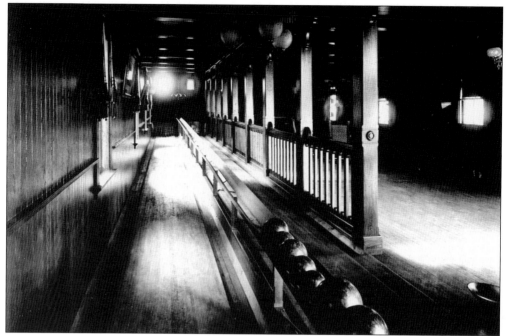

The bowling alley too got lavish attention. A cuspidor lurks in the lower right.

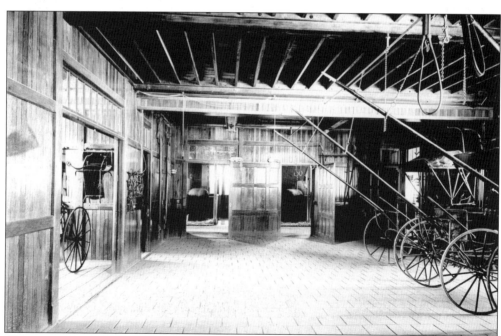

The carriage house was also immaculate.

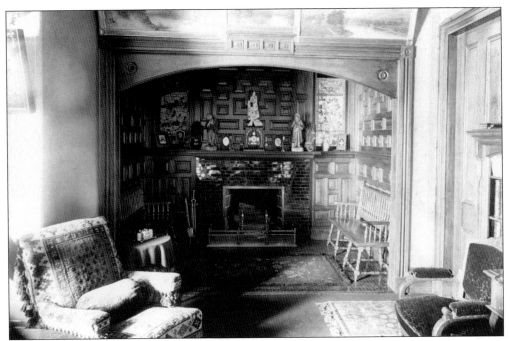

The fireplace nook would be a restful spot on a snowy evening.

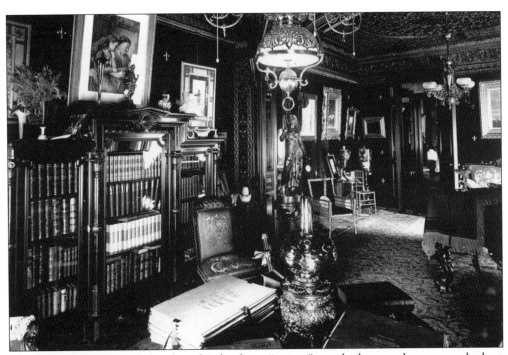

The elaborate library and the glassed-in books in "serious" matched sets make one wonder how much reading actually went on. A careful search reveals a banjo.

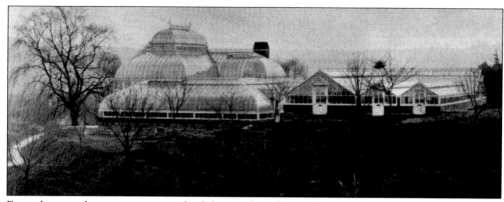

Even the greenhouses were not only elaborate, but elegant. It would be a great place to visit.

In fact, any place in Watkins is a fine place to visit.

Three

A STAY IN RESORTS

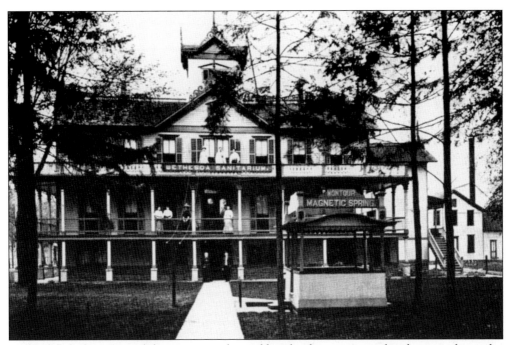

In the days before automobiles, resorts and grand hotels often accommodated visitors for weeks, or for a whole summer, with activities for every age. With the grand attractions of Seneca Lake and Watkins Glen, the Watkins region abounded with resorts, some of which also doubled as health spas. Bethesda Sanitarium in Havana boasted the Montour Magnetic Springs (under the gazebo in the foreground). What could be more energizing than a sanitarium summer, constantly sipping the health-giving waters?

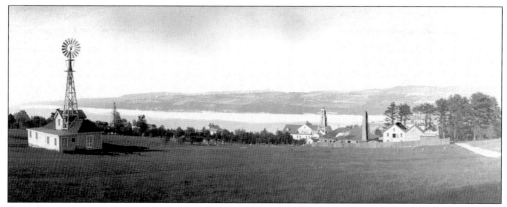

Glen Springs enjoyed wide grounds and a lovely view looking north up Seneca Lake.

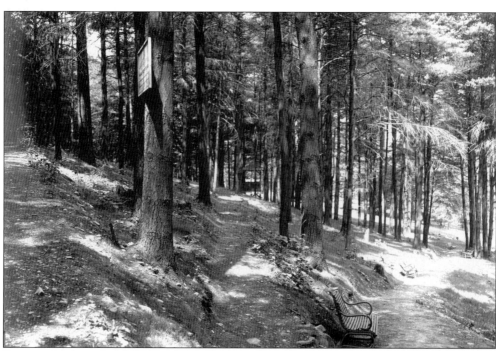

Rustic paths through the evergreens on the grounds of Glen Springs were scattered with benches.

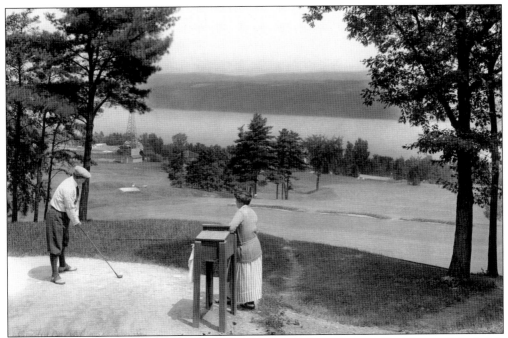

Even the golf course overlooked the lake. Look at the gentleman's tie and knickers and the lady's long skirt and cardigan.

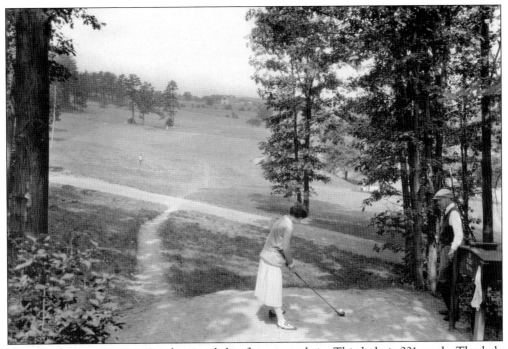

This gentleman sports a vest along with his flat cap and tie. This hole is 221 yards. The lady driving does not seem concerned about hitting the person standing in the fairway.

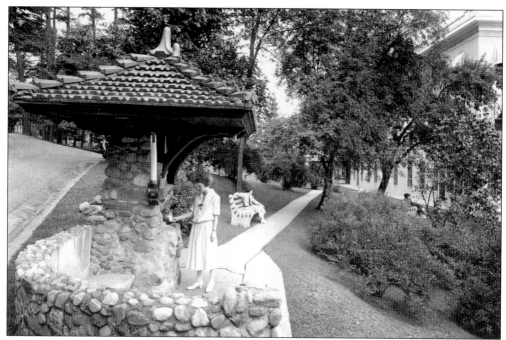

The roof of the spring itself was covered in terra-cotta, a specialty around Alfred, about 75 miles west. The structure, just visible at the right, later became a minor seminary and preparatory school named for St. Anthony of Padua.

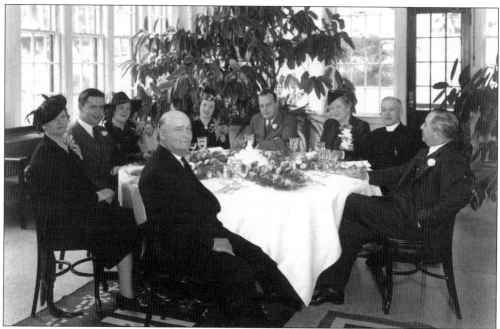

Glen Springs, with its endless windows, was a grand place for a wedding breakfast.

The drive to Glen Springs was worth a trip by itself.

Glen Springs was careful to cultivate the picturesque.

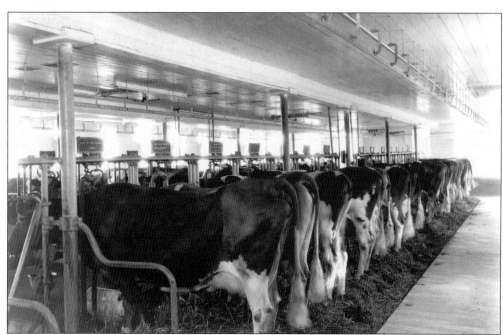

The dairy barn at Glen Springs was always busy.

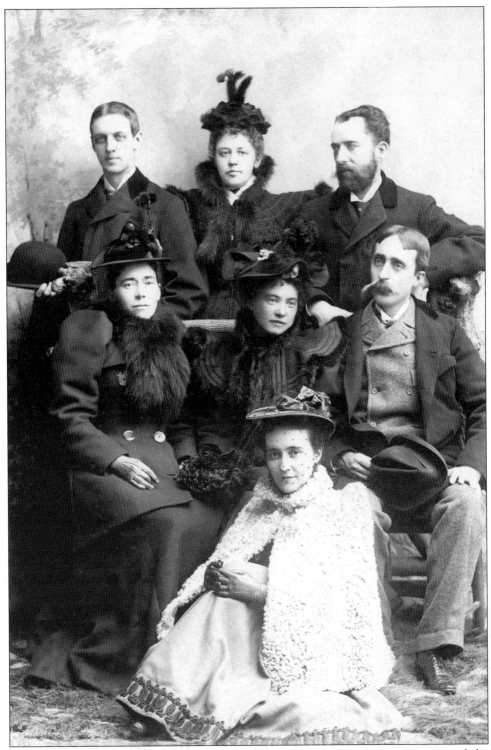

This 1903 group enjoyed themselves so much at Glen Springs that they commemorated their visit with a portrait by Fred Crum, a local photographer.

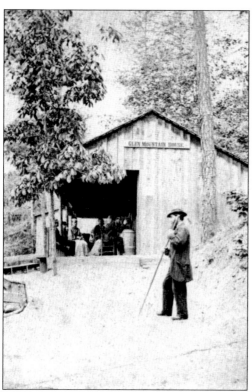

Mountain House (or Glen Mountain House), right above the gorge of Watkins Glen itself, hosted visitors from around the world. This appealing stereograph qualified for a series on New York scenery.

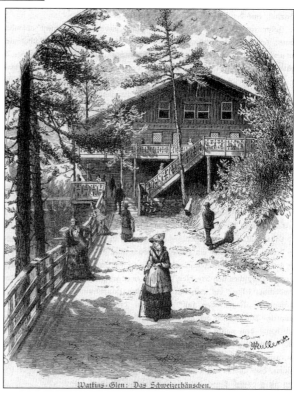

Watkins-Glen: Das Schweizerhäuschen.

This illustration displayed the main facility at Mountain House for German-speaking Europeans.

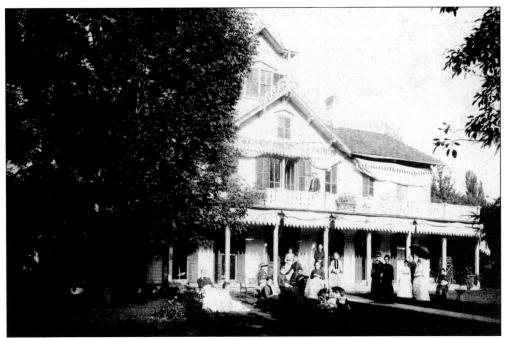

Dr. Charles Clawson looked after visitors to Bethesda. Built in 1876, the facility was enlarged two years later by raising it and adding a new first floor. It is a museum now.

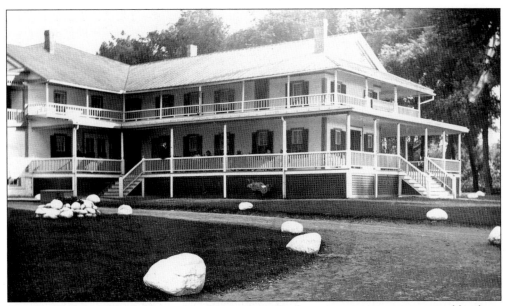

Sagoyewtha Inn at North Hector Landing presented a fine trim appearance, accented by those long railed porches wrapping around. An unidentified writer sent this postcard to Earl Shannon (RD 20, Dundee) in August 1907, reporting in somewhat confused spelling, "The wind was blowing and the waves were rolling and it was squirting some went I arive at Valois with out turning over." Lake traffic in those days, despite the obvious drawbacks, was often preferred to land travel.

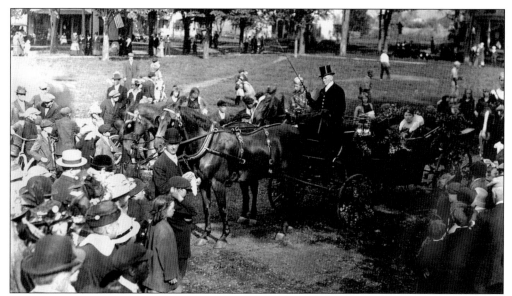

An early automobile at the top left proves that this photograph is not quite as old as it looks at first glance, but the crowd demonstrates that it can recognize a good team and a fine equipage. Horse-drawn vehicles hauled visitors from the depots to the hotels, and no doubt their elegance varied with the price one was ready to pay. The fellows in the right center are not interested—they have a ball game to play.

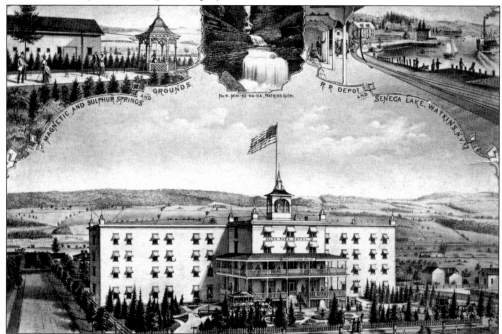

Glen Park offered magnetic springs and sulphur springs, the actual benefits of which would be interesting to know. This card, originally part of a stereograph, also shows a view (perhaps slightly enhanced) of the waterfront depot and the busy lake itself. The glen, of course, is centrally displayed at the top. Weekly rates ran from $2 all the way up to $15, but the horse-drawn bus from the depot was free.

Four

A Hike in the Glen

The Civil War was raging in 1863 when J. Morvalden Ells opened Watkins Glen as a privately-owned attraction, suggesting a rapidly extending transportation system, wartime prosperity, and increasing surplus time. Ells's brainstorm made sense. Americans, more and more citified, were following Europeans in their enthusiasm for nature. Nature was truly spectacular in the high cliffs, deep gorge, twisting stream, and dripping moss of the glen in Watkins. Of course, to be properly enjoyed, nature had to be helped along, with bridges, walkways, guard rails, and steps—all looking as rustic as possible. The glen became a state park (one of New York's most popular) in 1911. Mail by then was often being addressed not to Watkins, but to Watkins Glen, leading the village to change its name in 1926.

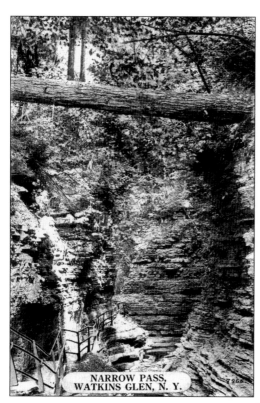

The work of eons is visible in the carving and the layering of the rock.

NARROW PASS,
WATKINS GLEN, N. Y.

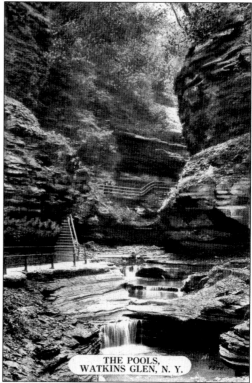

THE POOLS,
WATKINS GLEN, N. Y.

The cliffs catch the eye, but the water did the work.

60

Sometimes it spreads out in shallows, sometimes it narrows, deepens, and charges through gorges. Now and then it floods. But always, the stream goes through.

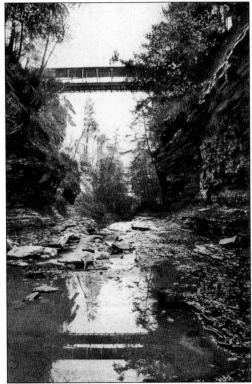

The freight train—once Northern Central, now Norfolk Southern—cuts across the park. Note the perfect reflection in the pool.

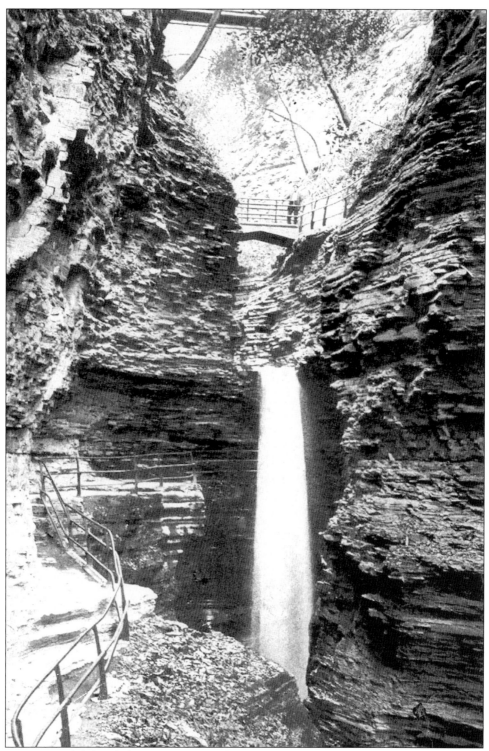

Visitors passed behind the Cavern Cascade and other spots, getting delightfully wet even beneath the overhang.

Try it out. It is wonderful on a hot day.

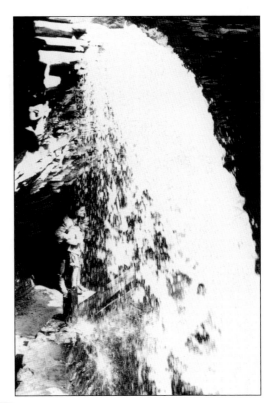

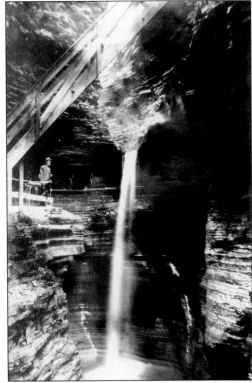

George Cornell took his family to the glen sometime around the beginning of the 20th century, also experiencing the wet, the cool, and the rumble. (Cornell.)

Notice the beautiful three tiers of the glen floor and the two bridges. (Cornell.)

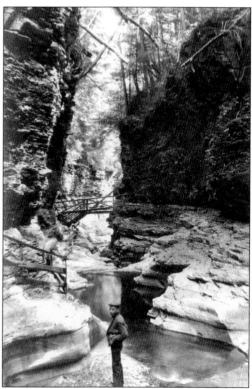

What a lovely place to explore, even with the heavy clothes of the day. (Cornell.)

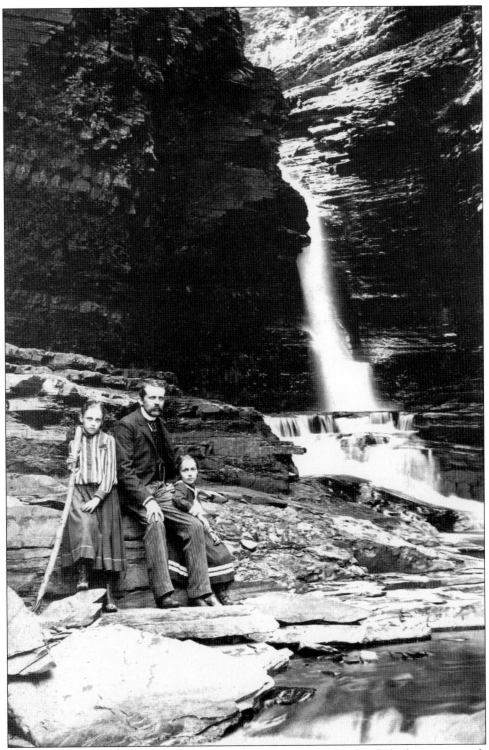

Men too "needed" high collars, three-piece suits, and cravats. This family looks worn out after their trek to this point—but imagine how the photographer, with heavy equipment, felt.

So famed, so singular was the glen that women explored all through, despite the almost overwhelming dress style "required" (complete with fancy hat) at the time. (Cornell.)

Safety was an obvious concern, right from the start.

While temptation traditionally leads downward to the very bottom, it can also lead upward to the very top. This photograph is marked, "Victim 1st today." Emergency workers must have been deeply exasperated.

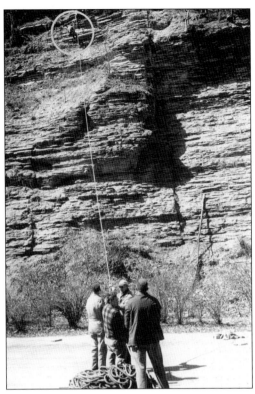

One stairway alone requires 123 steps, but most are much more friendly.

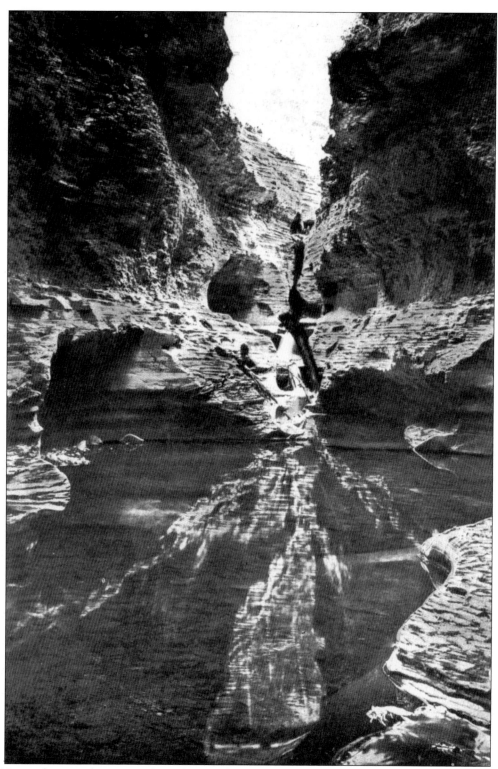

Notice the curved openings that Glen Brook has gouged out in the Fairy Pool.

Ice transforms the glen into a whole new wonderland.

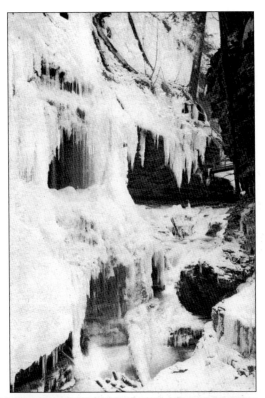

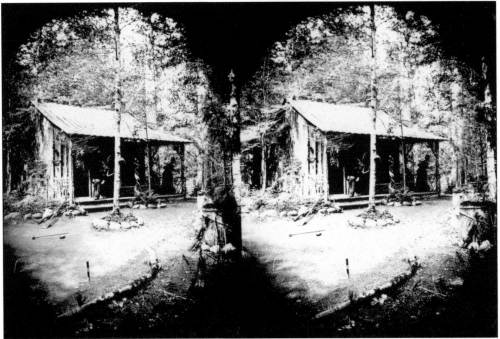

This rustic cabin, from a lovely stereograph, has a croquet set in the cleared space. A long gun and a broom (or possibly shovel) lie on the rocks at left. Two people on the porch are scarcely visible because of shadow.

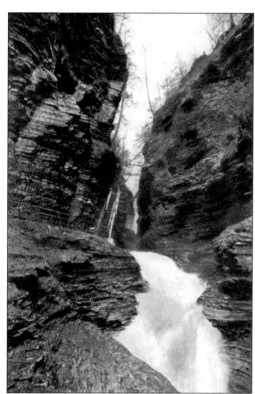

Minnehaha Falls is one of the favorite tourist stops along the gorge.

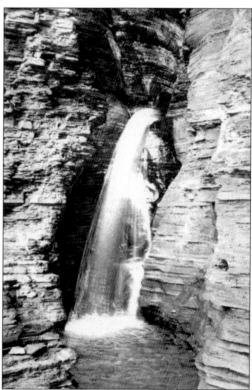

The cascade is the first water fall seen when starting a hike up the gorge from town.

70

Pictured is the Flying Stairs Bridge at Rainbow Falls, another popular photo opportunity.

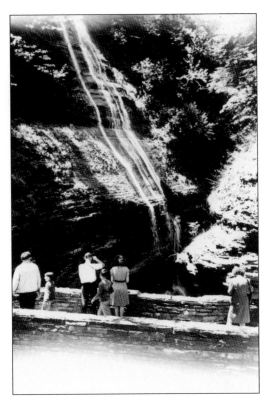

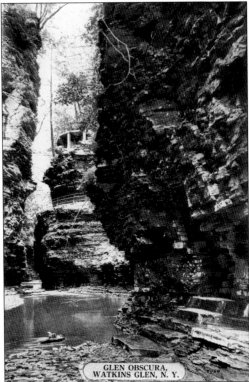

Glen Obscura is one of many points from which one can see the trail winding above. The faint of heart need not fear, they can walk down, rather than hike up, the trail.

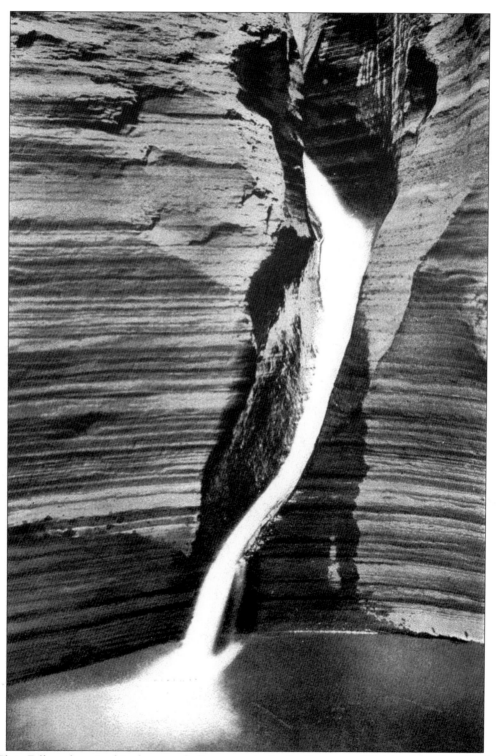

Pluto Falls, at least in this photograph, lives up to its foreboding name. Watkins Glen State Park now attracts up to a million visitors a year.

Five

A Day at the Races

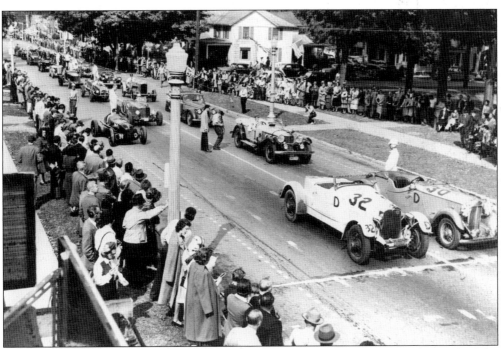

By 1948, the war was slouching into memory, and America's bright new future boomed. In the lakeside village of Watkins Glen, tens of thousands suddenly crowded the streets, hay bales lined the sidewalks, and weird-looking vehicles revved their engines. For years, the race was a true grand prix, taking off in front of the courthouse on Franklin Street, tearing through White's Hollow, rushing across railroad tracks (officials stopped the train), sliding down a long steep hill, whipping through the sharp turn in front of the Flatiron Building, turning right onto Franklin Street, and roaring down the stretch, back to the courthouse and the finish line. (International Motor Racing Research Center.)

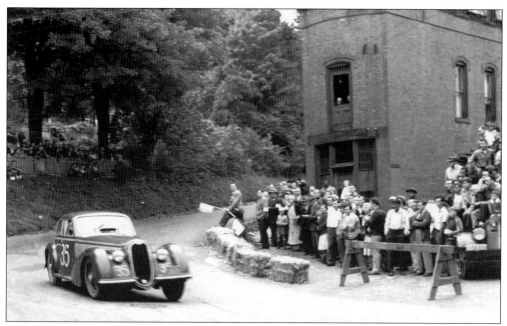

In the very first year of racing, Frank T. Griswold pulled his Alfa Romeo 2900B hard to the left at the foot of a long steep slope, cautioned by a flagman on the hay bales. Griswold won both the grand prix and the junior prix that year. This dangerous turn by the Flatiron Building (old post office) is still called Millikan's turn, from Bill Millikan's memorable wipeout on the spot. Millikan, happily, was still going strong in 2006. (International Motor Racing Research Center.)

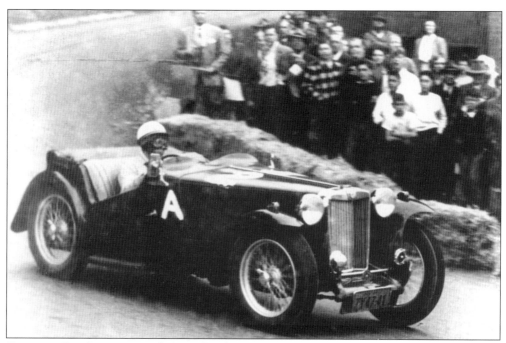

Cameron R. Argetsinger also made the turn in 1948. (International Motor Racing Research Center.)

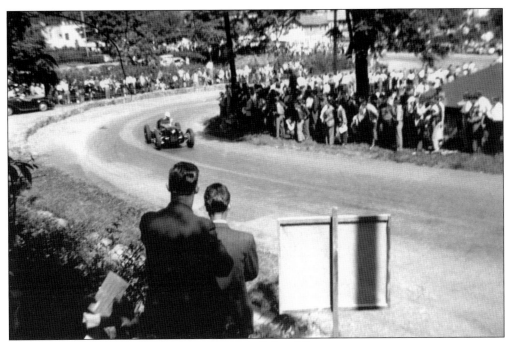

George Weaver roars to victory in his Maserati, *Poison Lil.*

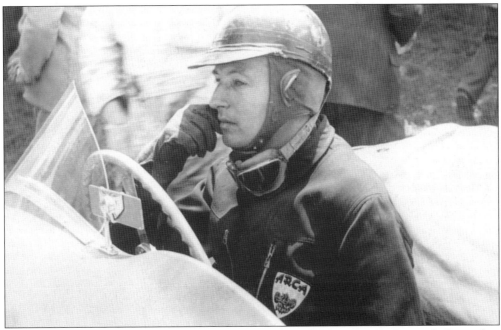

Sam Collier is still a revered name in racing. (International Motor Racing Research Center.)

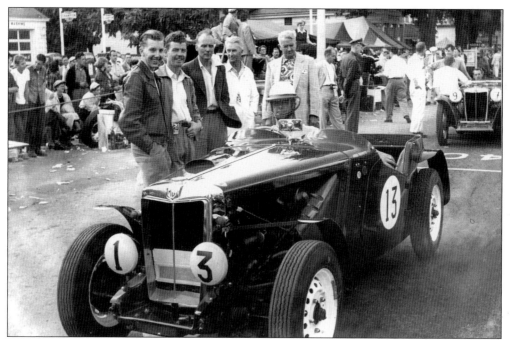

C. Gordon "John" Bennett ran a supercharged MGTC in the 1952 grand prix. (International Motor Racing Research Center.)

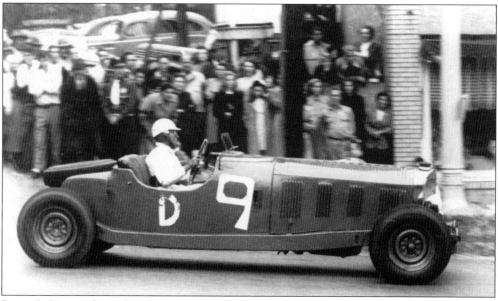

Briggs S. Cunningham placed second in the 1948 junior prix and grand prix overall. (International Motor Racing Research Center.)

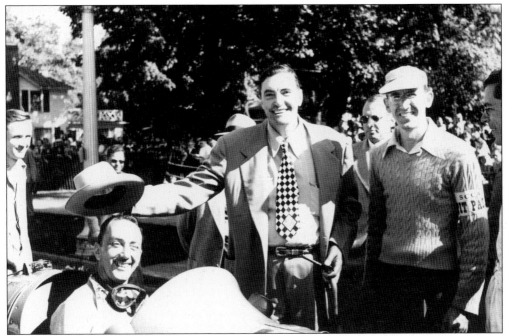

George B. Weaver, racing a 1936 Maserati RI, won the 1949 and 1951 Seneca Cup races. Standing left to right beside Weaver's car are Deacon Litz and Phil Cade (wearing a pit pass armband). (International Motor Racing Research Center.)

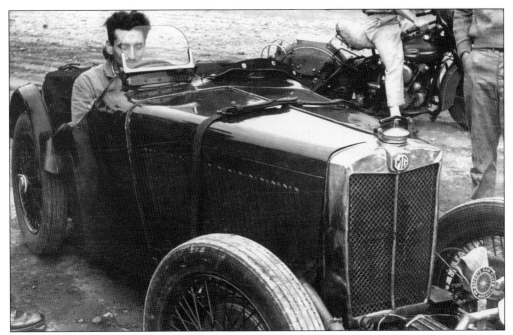

Otto Linton ran an MGTC, a popular racing vehicle at the time. Note the motorcycle in the background. (International Motor Racing Research Center.)

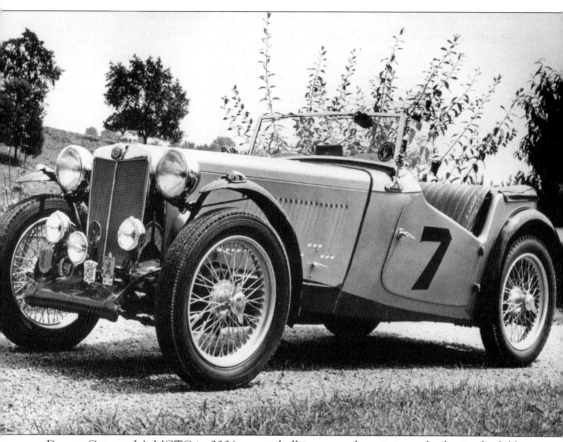

Denver Cornett Jr.'s MGTC in 2006 arrested all interest where it is on display in the lobby at the International Motor Racing Research Center at Watkins Glen. (International Motor Racing Research Center.)

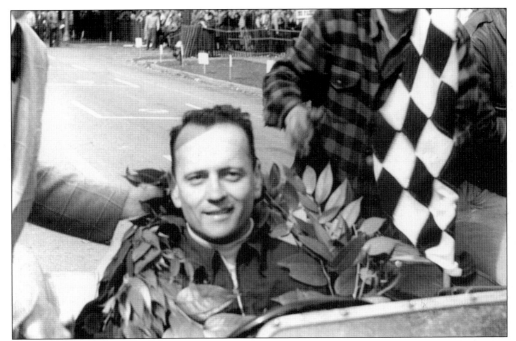

Phil Walters wears the laurel after winning the 1950 Seneca Cup in a Cad-Healey Silverstone. (International Motor Racing Research Center.)

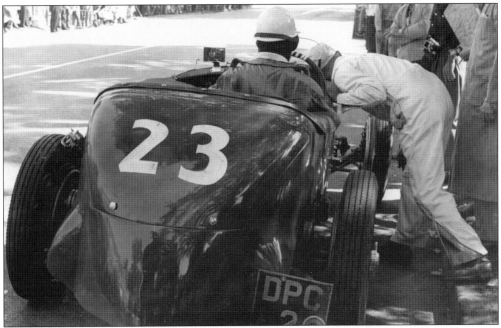

George Huntoon, in his Alfa Romeo 8C2600 Monza, gets some advice for the 1949 grand prix. Notice how close, and how casually, the spectators stand. (International Motor Racing Research Center.)

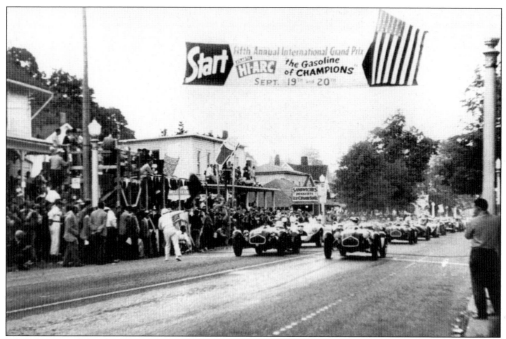

And they're off for the fifth annual road race. The 1952 grand prix roars into action. (International Motor Racing Research Center.)

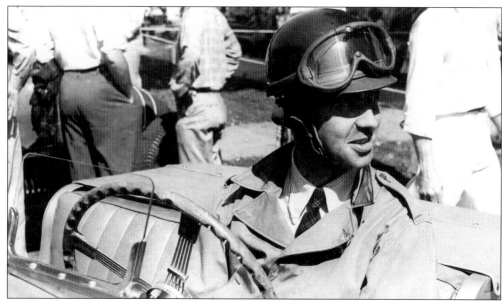

Ledyard H. Pfund raced a Ford Special in 1949. Notice the necktie and buttoned-down shirt. (International Motor Racing Research Center.)

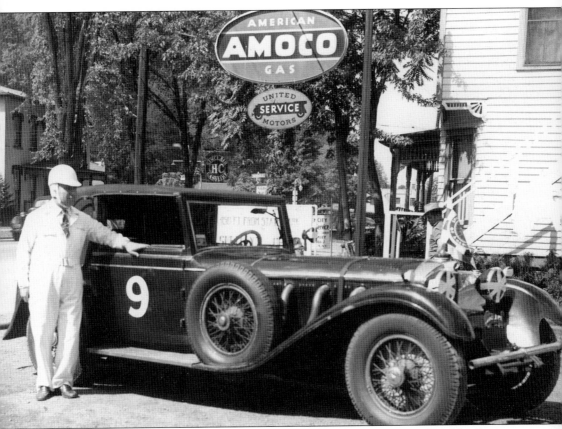

Dud C. Wilson (and his Mercedes Benz) makes a stop at Smalley's Garage on Franklin Street in 1949. (International Motor Racing Research Center.)

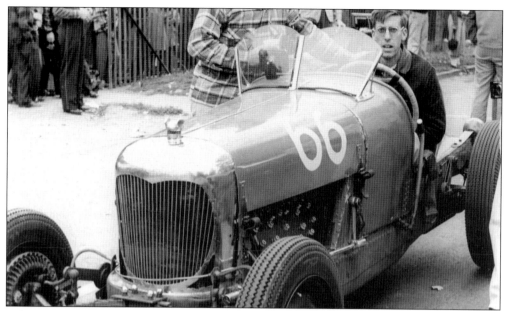

Robert J. Wilder tackled the 1950 Seneca Cup with his Ladd Special, or, as it was sometimes called, *The Old Grey Mare*. (International Motor Racing Research Center.)

Robert Grier (BMW Coupe) and Richard Haynes (Fiat 1100s) race down Franklin Street for the grand prix in 1949. (International Motor Racing Research Center.)

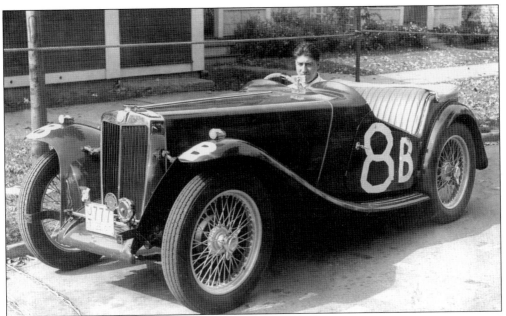

Haig Ksayian drove this supercharged MGTC to third overall in the 1948 junior prix and grand prix. (International Motor Racing Research Center.)

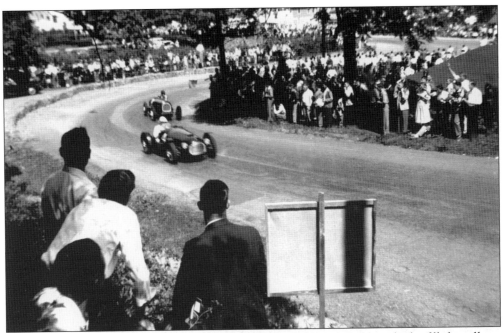

Although today's races are run in a closed track, now and then vintage vehicles fill the village. And anyone who follows the map and keeps to the speed limit can drive the original course. With a little imagination, one is back in the days when the dictators were gone, the Depression was over, and the only thing ahead was the long, wide, open road.

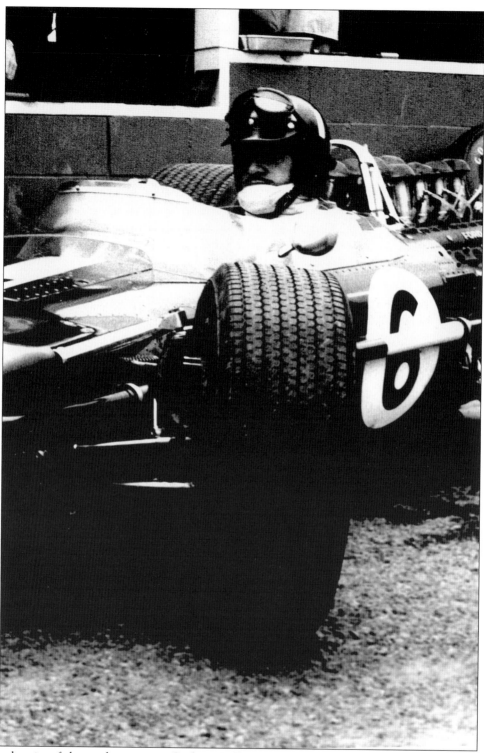

In the pits of the modern course, Graham Hill waits intensely for the 1966 U.S. Grand Prix to begin.

Six

A RAMBLE
THROUGH SCHUYLER

Schuyler County has woods and hills,
vineyards and wineries, Seneca Lake and
little lakes, churches, towns, hamlets, and
villages—it is fun to explore. Climb aboard.

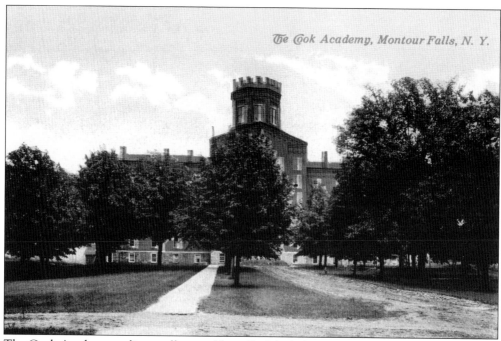

The Cook Academy, earlier a college and later St. John's Atonement Seminary, is now home to the New York State Academy of Fire Sciences.

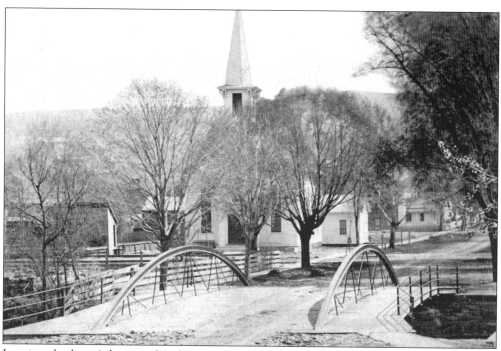

Imagine the horse's hooves clip-clopping over the old South Street bridge in Montour Falls. Notice the blossoming branches on the right—spring is coming.

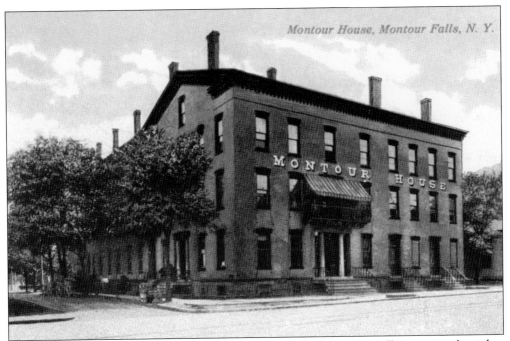

The imposing Montour House in Montour Falls (originally Havana) is still impressive, but it has not been put to much use for some years.

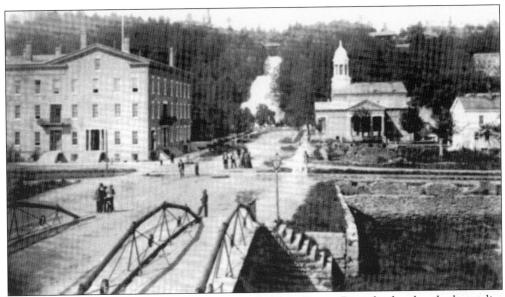

What a dramatic sight greeted those turning onto Main Street. Directly ahead and athwart lies the Chemung Canal. Montour House is on the left, a bank (now the library) and courthouse (now village hall) are on the right. Right at the head of the street, of course, thunders Chequaga Falls.

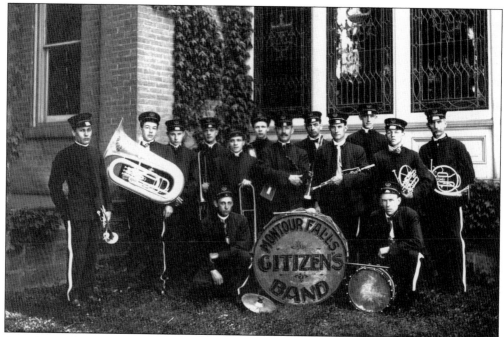

Outside the library became a favored spot for group photographs. Back around 1911, the Citizen's Band gave free concerts every second Saturday through the summer from the balcony at the Blue Bottling Works.

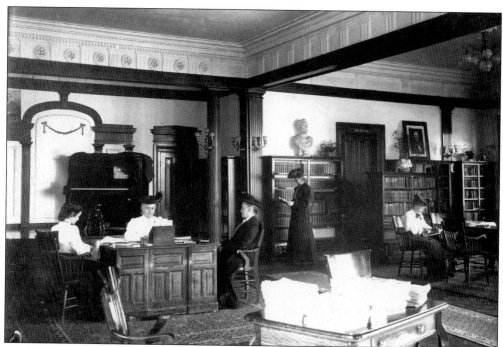

Inside the library, decorum and quiet were sternly maintained, right down to the librarian's elaborate hat. The daring young woman at left, however, gets along fine without one.

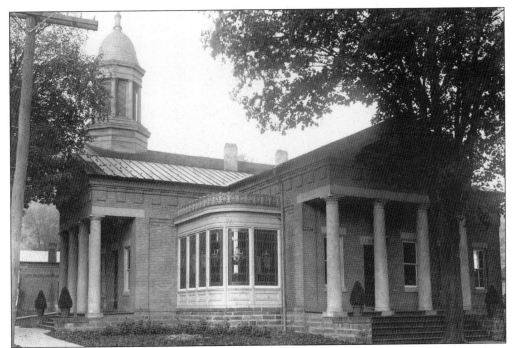

Stand inside the library and look at the world through that curved array of windows. It makes a wonderful sight.

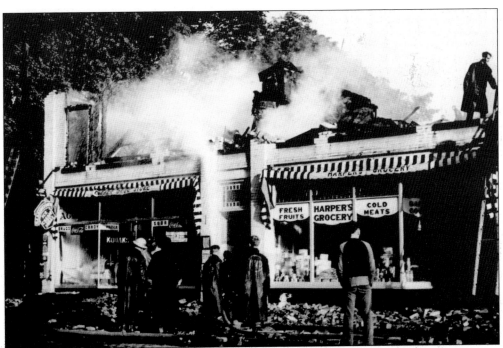

Harper's Grocery and the Corner Drug Store would appear to be complete losses. A sad fate for such neighborhood treasures.

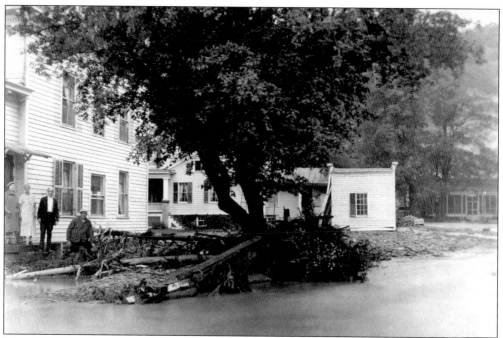

Montour Falls and Watkins Glen suffered badly in the 1935 flood, as did many towns in the region. One person was killed in Schuyler County.

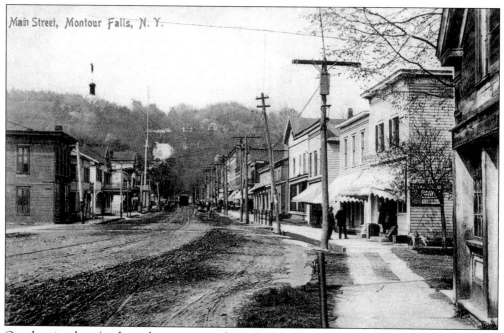

On cheerier days (such as this one around 1909) the falls behaved themselves, and the town slept easy. Notice how the utility poles clearly are trimmed trees. Notice also how this postcard immortalizes one dog's visit to the fire hydrant (on right, below the Sherwin Williams sign).

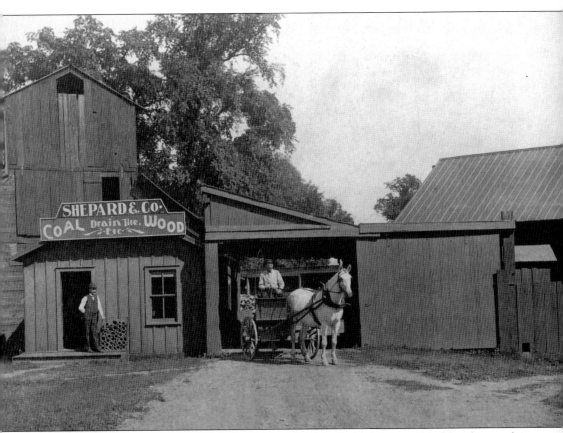

The Shepard Company specialized in coal, wood, and drain tile in this location along the canal in Montour Falls.

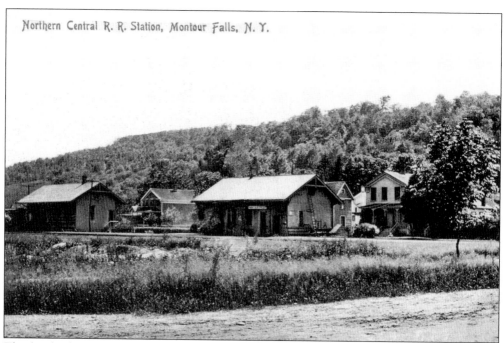

Northern Central R. R. Station, Montour Falls, N. Y.

The freight depot is now a doctors' office.

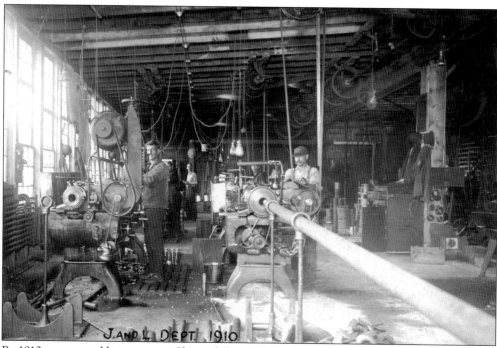

J. AND L. DEPT. 1910

By 1910, cranes and hoists were a Shepard (later Shepard Niles) specialty. Notice that there are no shields on the machines and no safety glasses. Both are required in a machine shop today.

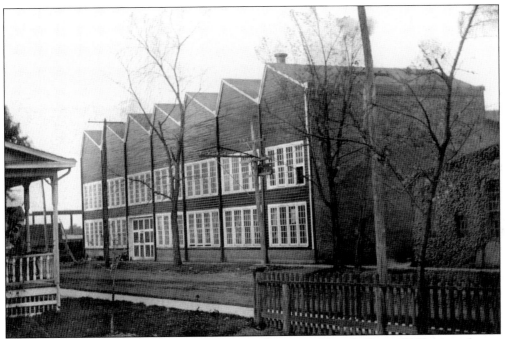

Facilities grew accordingly. These facilities are still in use, although Shepard-Niles is no longer in business in Montour Falls.

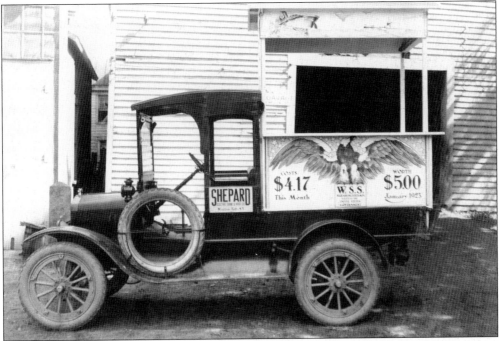

A beautifully decorated truck, with eagle below and sinking ship above, boosted Liberty Bond sales in World War I. In 1945, a Shepard Niles electric hoist lifted the Trinity atomic bomb to its place on the tower near Alamogordo, New Mexico.

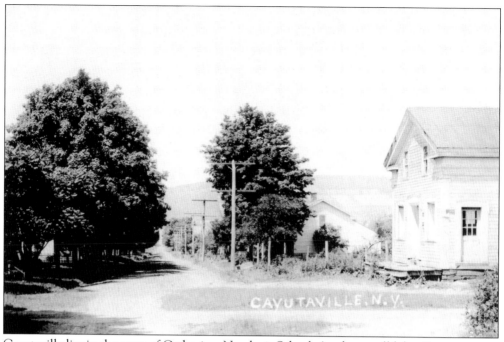

Cayutaville lies in the town of Catharine. Nearby is Schuyler's other small lake, Cayuta.

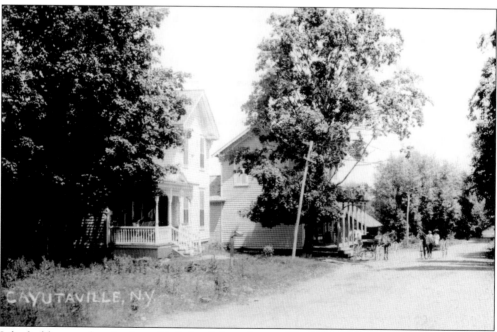

It looks like a perfect day for a ride behind those horses. The store that those buggies are stopped at is probably also the post office. Notice the listing telephone pole.

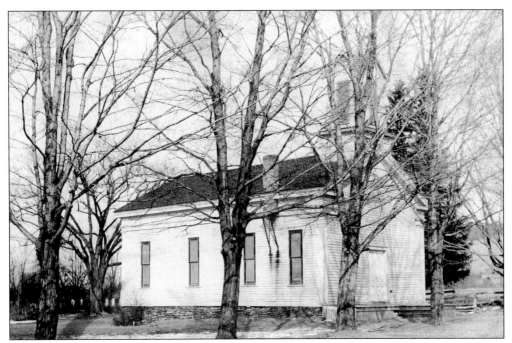

Cayutaville Church eventually burned.

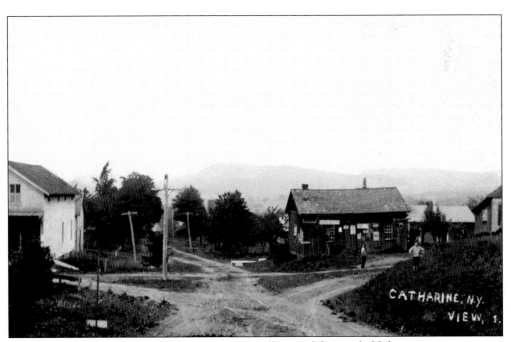

CATHARINE, N.Y.
VIEW, 1.

Dirt roads, paintless sheds, and short pants were all part of the good old days.

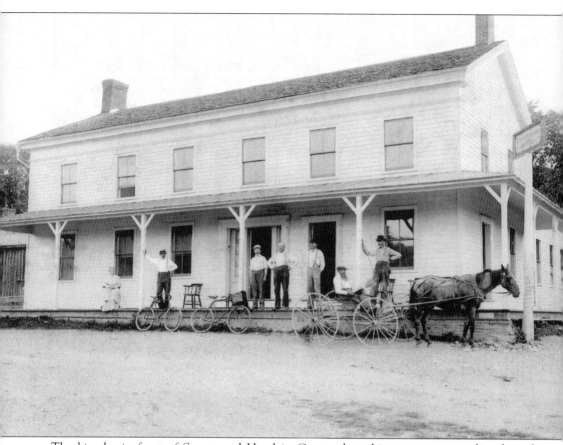

The bicycles in front of Swartwood Hotel in Cayuta date this scene as no earlier than the 1890s. One of the bicycles has a case on the front that looks as if it probably belonged to the photographer who took this image. The old gent in the carriage is being very casual reading a newspaper.

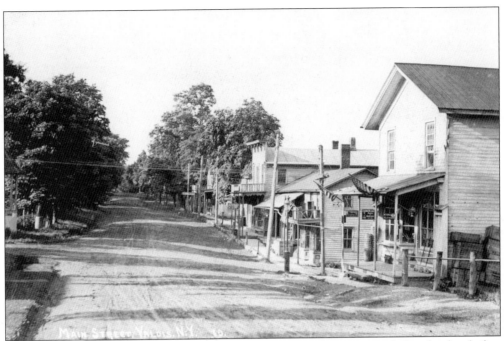

Valois was never a huge community, but look how many retail stores it needed in the days before easy travel. The shop on the right (with lawn mowers on the porch) is a hardware store. A sign reads Telephone Pay Station.

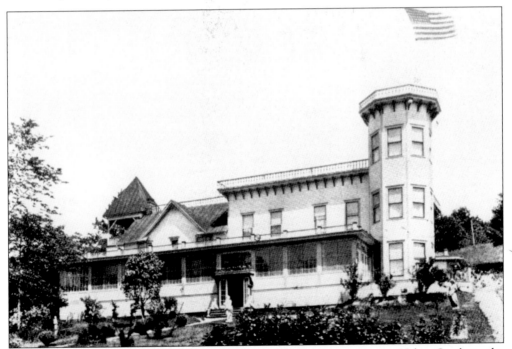

The wealthy Count Valois (as he was remembered) built the extravagant Valois Castle in the community that later absorbed his name. The castle, later a hotel seen here in a postcard image, has since burned down.

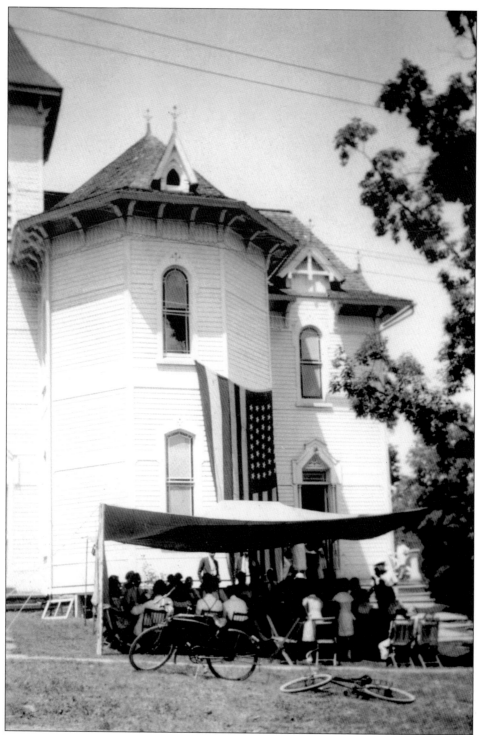

This would appear to be some patriotic occasion with the large flag in the background. Whatever the reason for the gathering, it is a fine summer day for an outdoor activity. Mecklenburg Church is still home to an active United Methodist congregation.

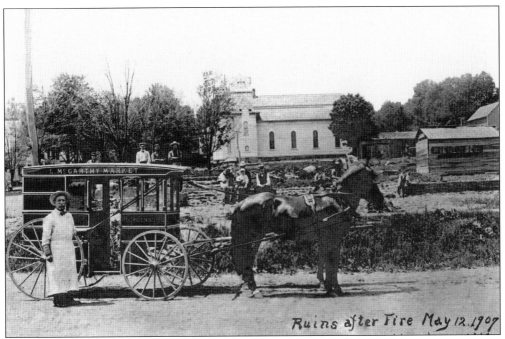

The fire was clearly devastating, but the groceries must go through.

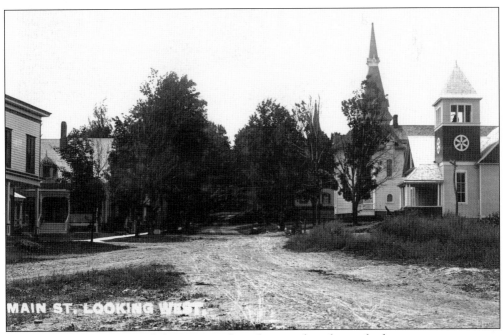

The churches are lovely, and the grass on the right is ready to be scythed.

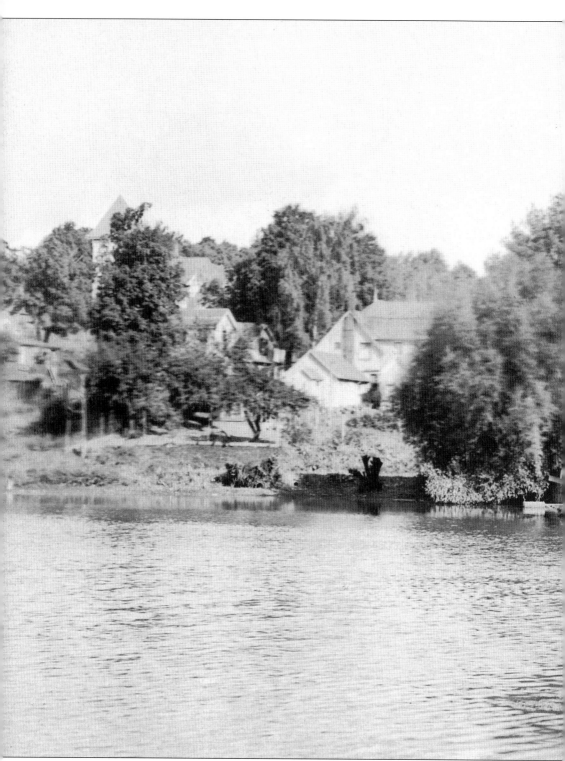

Seneca Lake is far from the only body of water in Schuyler County. Some of the smaller lakes and ponds are even lovelier. Mecklenburg Pond, shown here, is no exception. It probably was at

one time a mill pond to provide waterpower for some local industry.

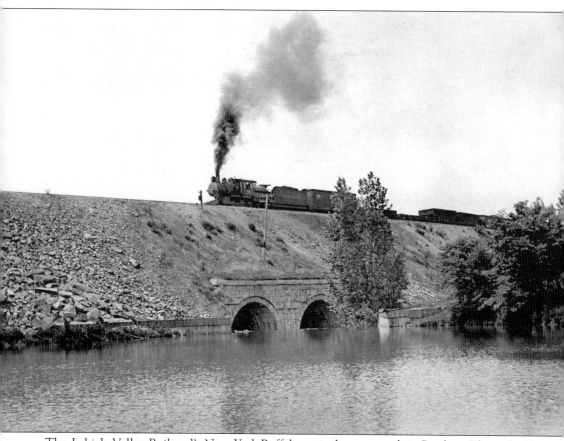

The Lehigh Valley Railroad's New York-Buffalo main line stopped in Burdett. These double arches are a local landmark.

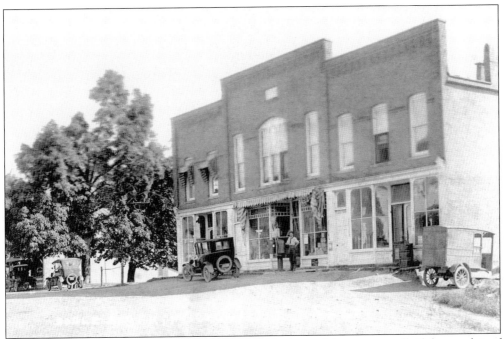

The mercantile interests in Mecklenburg's Bodle Block are doing pretty well, if the number of vehicles is any indication. The center store is a grocery, and the youngster out front is posing by the gas tank. A hotel stood directly across from the Bodle Block's far corner, with another retail store past that.

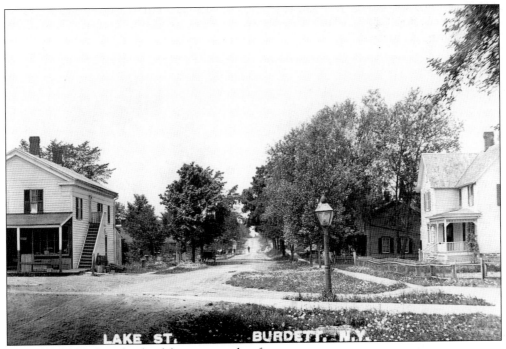

In a setting like this, the dandelions are works of art.

Today it might seem pretentious, but long ago many small communities boasted opera houses, although they probably hosted other entertainments far more often than operas. An opera

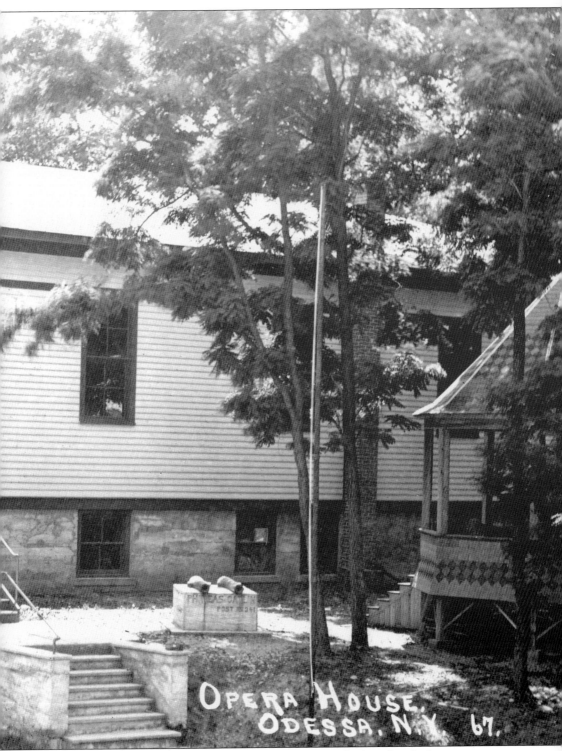

OPERA HOUSE.
ODESSA, N.Y. 67.

house provided small villages a venue for cultural events whether they be lectures, concerts, or vaudeville.

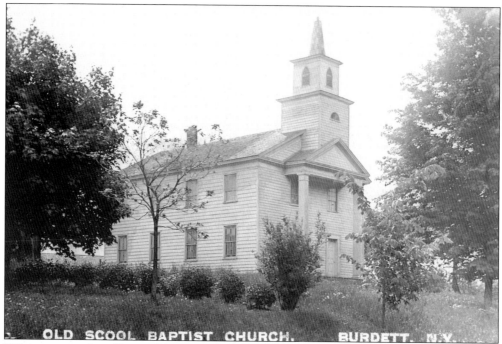

OLD SCOOL BAPTIST CHURCH. BURDETT. N.Y.

Whoever wrote "scool" must have missed a few days of class.

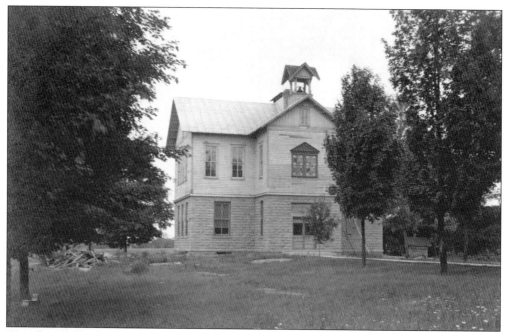

This is a good-sized facility for the days before centralization, especially considering how few students progressed this far. It is a fine design, too, right up to the bell in its tower. Notice the lumber on the left. Perhaps this dates to 1906, when Odessans expanded their school by raising it and placing a new story underneath.

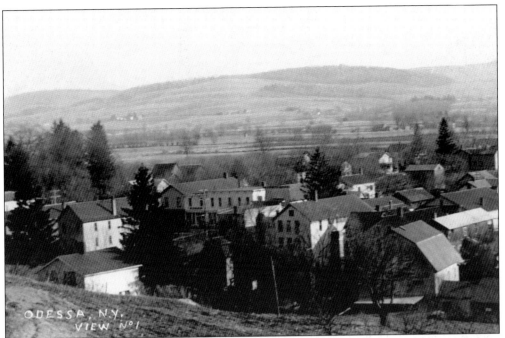

The photographer banked on Odessans wanting views of their community; but look at those beautiful hills beyond. Maybe he intentionally took the photograph for the postcard in the winter, when the trees were bare to better show off the buildings.

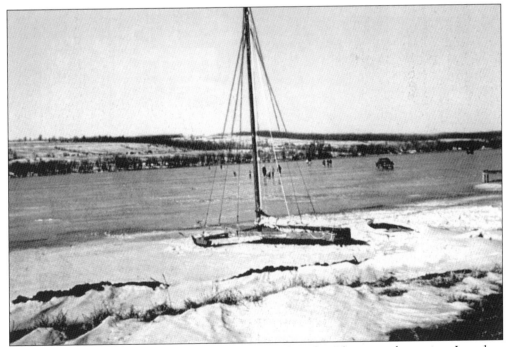

Waneta (shown here) and Lamoka are the two "Little Lakes," home to the ancient Lamokan Culture, first discovered and identified near the channel between the two lakes. Ice-skating, iceboating, and ice fishing are popular, and, once upon a time, so was driving a car on the ice.

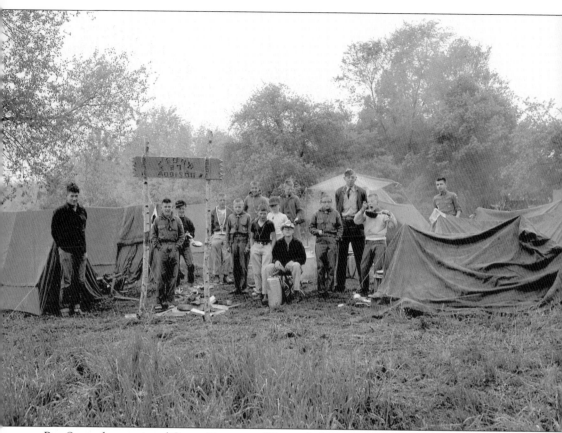

Boy Scouts have enjoyed Camp Gorton on Waneta Lake (once Little Lake) for decades. Addison Troop 27 set up under canvas back around 1960. Coauthor Charles Mitchell was earlier a member of Troop 27 and spent many summers at Camp Gorton. His grandfather Ralph B. Dykins took this photograph. Boy Scout Camp Seneca (now gone) operated in the Finger Lakes National Forest, also in Schuyler County.

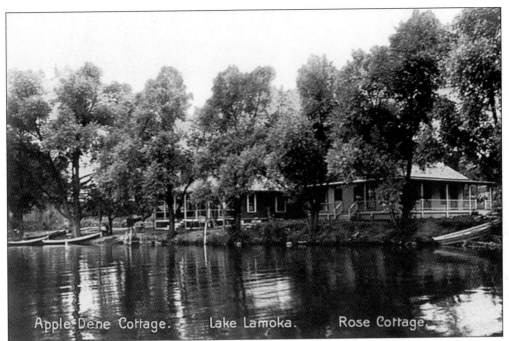

Apple Dene Cottage. Lake Lamoka. Rose Cottage.

Lamoka Lake (once Mud Lake) is another hidden Schuyler County treasure. Besides many cottages like these shown here, it also hosts Camp Lamoka (Baptist) near Tyrone.

Jack in Tyrone sent this postcard to Sarah Stevens in nearby Weston (it went through Dundee first, in May 1908), showing the family's house and lot, and mentioning a hail storm. Lamoka Lake is visible in the background.

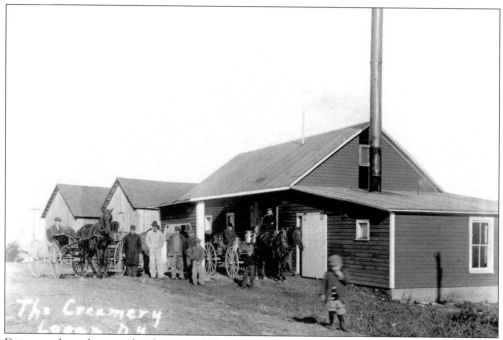

Dairy products became big business before dairy farming did. Most farmers, whatever their specialty, kept a few milkers on the side, and the railroads had milk runs to collect each day's produce.

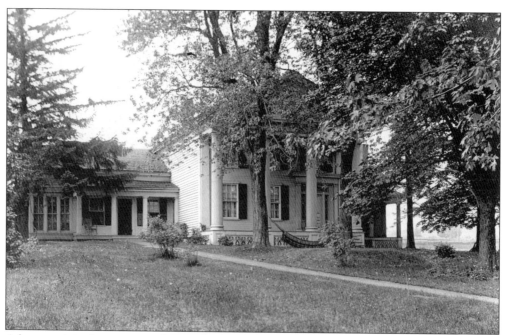

A hammock in the trees, a rocker on the porch, what better way to enjoy a perfect summer day. Notice the fancy grillwork skirting the Greek Revival "big house."

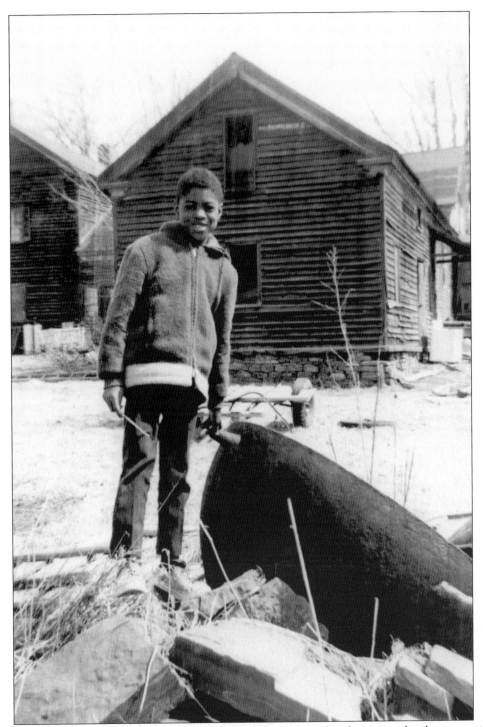

It is likely that several Schuyler sites, including this one with a huge iron kettle among its remains, were on the route of the Underground Railroad. It is usually difficult to establish exactly which houses were on the Underground Railroad because they were, by necessity, closely guarded secrets.

The 1844 Luther Cleveland house on Lake Road in Reading appears to have been an Underground Railroad station beginning in 1850. This particular route followed the line of the Northern Central Railway from Philadelphia through Harrisburg, Pennsylvania, and Reading (in Schuyler) to Niagara Falls. Instead of a carriage block, the Clevelands have a platform with steps up and down.

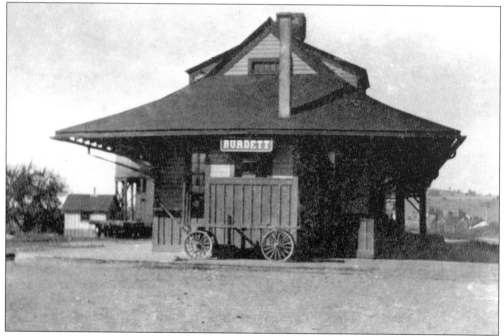

The Lehigh Valley station in Burdett, while not tiny, is certainly not huge, but it was the closest that rail line got to Watkins Glen. Wagons met them here, and for thousands of travelers heading to resorts, this was the doorway into summer.

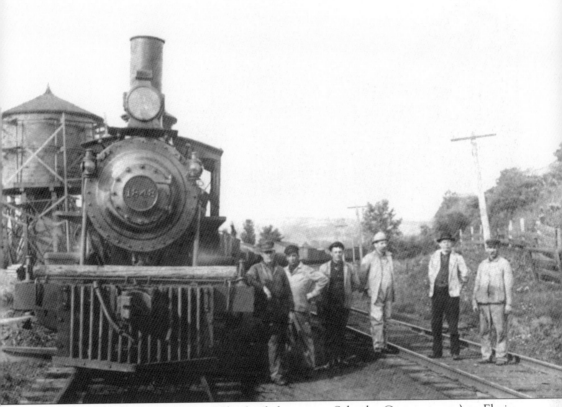

At one time canals joined Seneca Lake (and thus many Schuyler County towns) to Elmira, Keuka Lake, and the Erie Canal System. The Cayuga-Seneca canal is still in action, but the others vanished with the advent of the railroads, such as this Northern Central Railroad locomotive and crew shown near Watkins Glen.

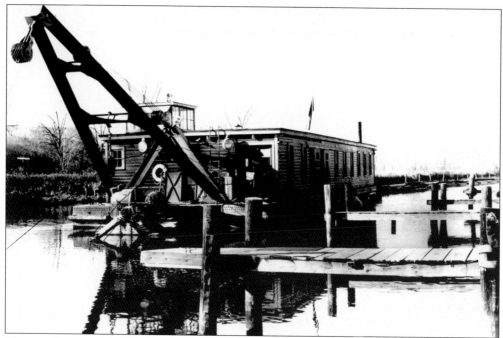

The canal just outside Watkins Glen conveys boaters between the marina and Seneca Lake. It also drains the Catharine Marsh into the lake. Sometimes it needs dredging.

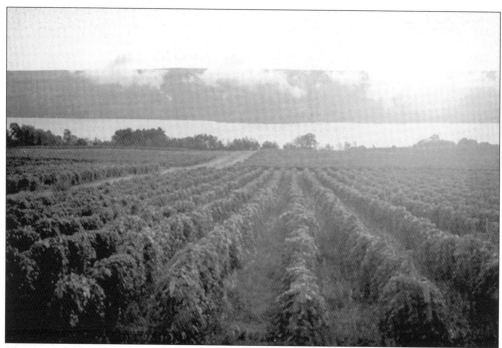

The entire Finger Lakes region is a well-known grape and wine region, and Keuka Lake is the granddaddy of the business. But the vineyards and wineries of Seneca Lake, such as this one of the west side, have surpassed Keuka in volume and rival it in quality.

SENECA, Queen of the Finger Lakes

After the Civil War, Finger Lakes wineries became tourist attractions. The process hastened after World War I, when America bought cars and area leaders improved the roads. Today Schuyler County's wineries are equal to the lake, the glen, and the track in drawing tourists to the area.

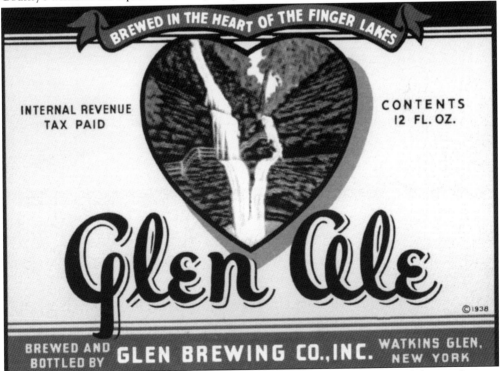

BREWED IN THE HEART OF THE FINGER LAKES

INTERNAL REVENUE TAX PAID

CONTENTS 12 FL. OZ.

Glen Ale

©1938

BREWED AND BOTTLED BY GLEN BREWING CO., INC. WATKINS GLEN, NEW YORK

Notice that this ale label has a copyright dated not long after the repeal of Prohibition. Seventy years later, mountain springs remain prominent in the promotion of beer.

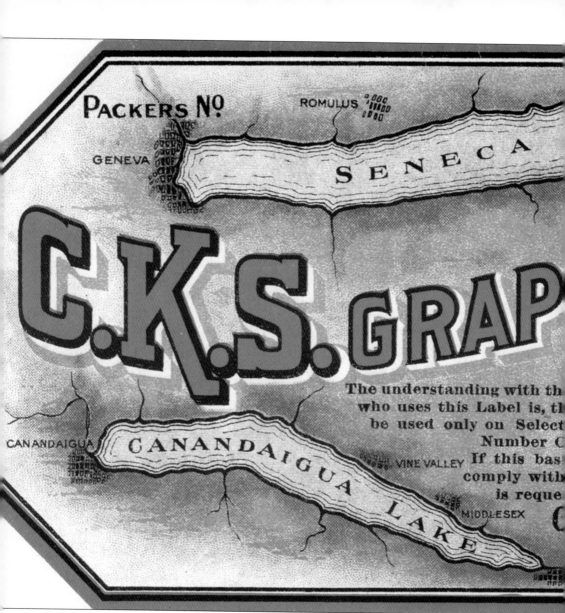

On this historic grape label, the packers number (upper left) would identify each grower for payments and evaluations. (For those not familiar with the Finger Lakes geography, note the north arrow over Seneca Lake at the top of the label). These growers banded together in a

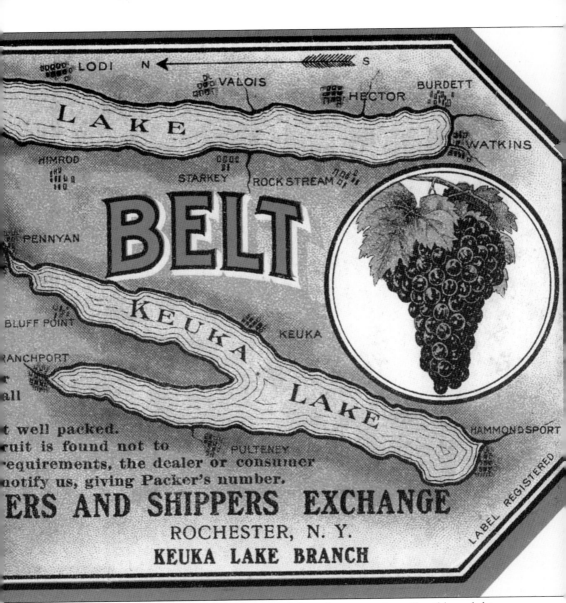

cooperative for packing and marketing. These labels have become quite collectible and this one especially so.

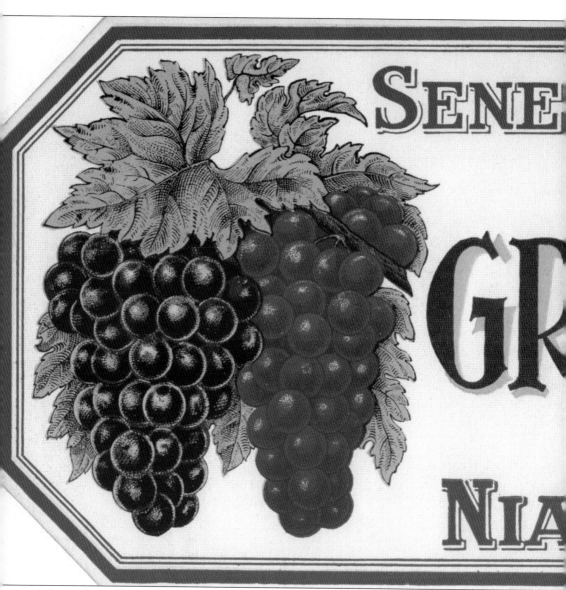

Packers pasted these labels onto the lids of two-pound pony grape baskets for shipping eating grapes to nearby cities. Niagara was only one of the many varieties grown. The baskets were

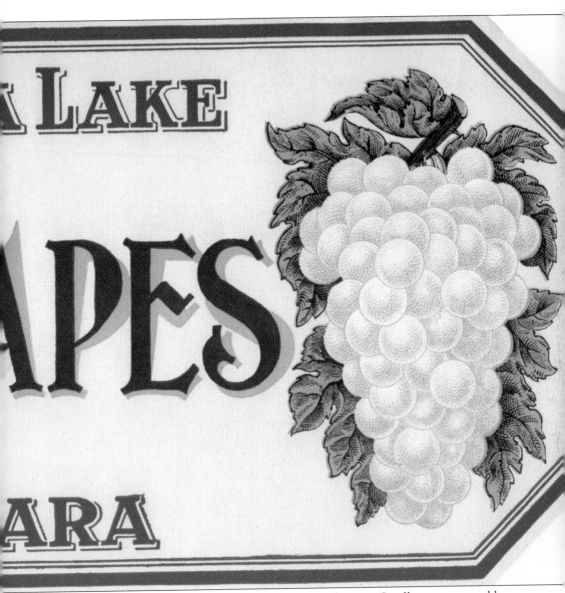

locally made, in the millions each year, using trees cut in the area. Smaller growers would use these generic labels. Today most grapes go for wine rather than fresh fruit.

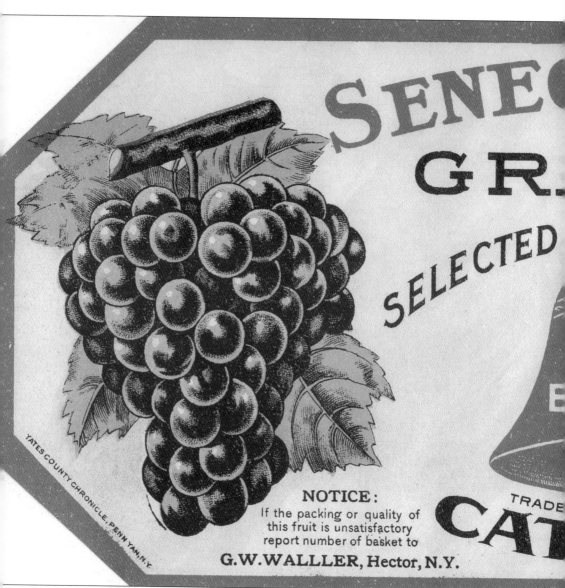

SENE

GR.

SELECTED

CAT

TRADE

B

YATES COUNTY CHRONICLE, PENN YAN, N.Y.

NOTICE:
If the packing or quality of
this fruit is unsatisfactory
report number of basket to
G.W. WALLLER, Hector, N.Y.

Notice that this label was printed for a Hector (east side of Seneca Lake) grower. Growers took great pride in their baskets of eating grapes as shown by the statement "If the packing or quality

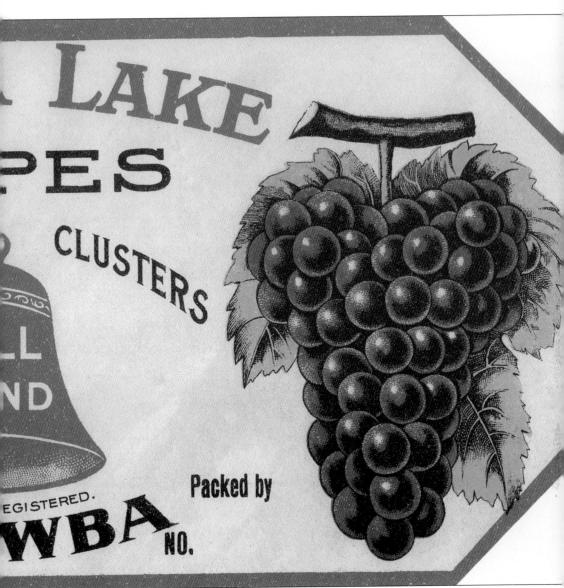

of this fruit is unsatisfactory report number of basket to . . ."

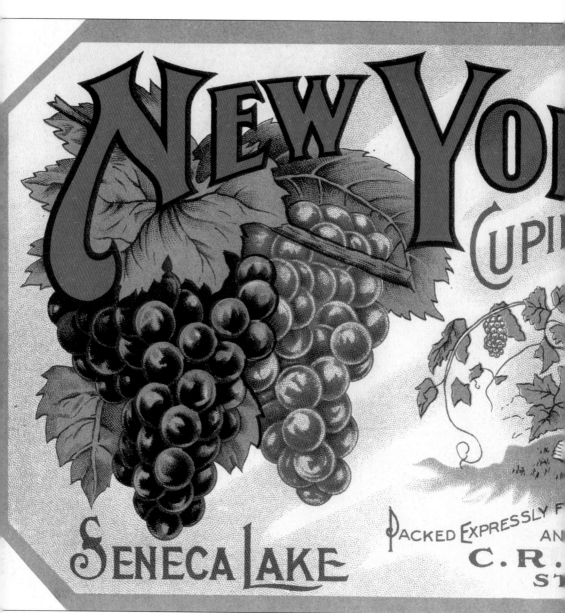

Grape labels (usually in bright colors) were often elaborate and beautiful, as shown by this label for a grower in Starkey—a little outside Schuyler, but still on Seneca Lake. Why he chose Cupid

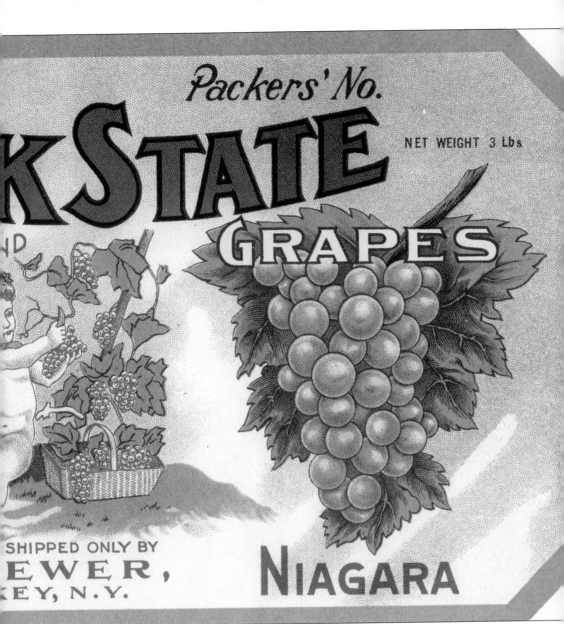

is unknown. He probably would have shipped his grapes to Watkins on a steamboat from his dock on the lake, or by rail from Himrods Junction.

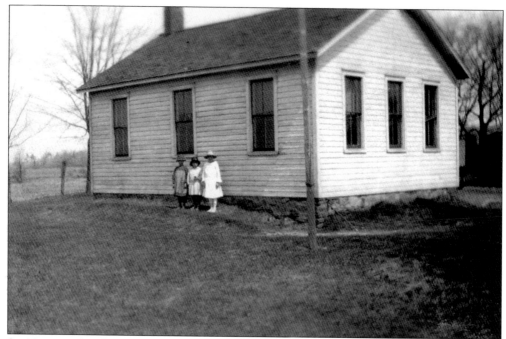

Six Nations schoolhouse in the town of Orange served a small community named for the region's original owners. These three girls seem so tiny next to the school building.

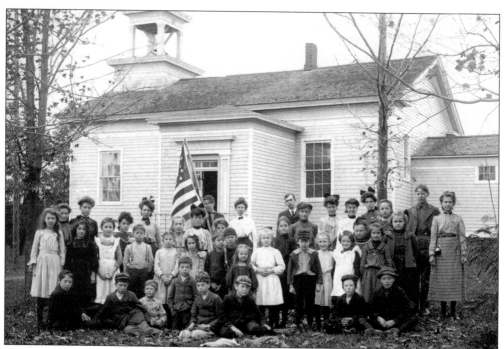

This multiroom school has its own bell. There appear to be three or four teachers in the photograph. The slight age difference between the girls and the female teachers makes it difficult to tell them apart.

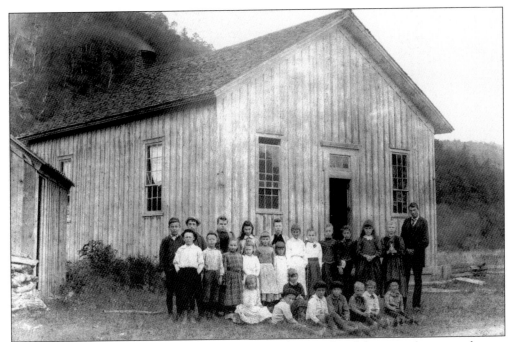

Both men and women taught in America's tiny schools, some for a lifetime and some on the way to "better things." This rather dreary school has a split-rail fence to the right. It must be a chilly day, as smoke is pouring from the chimney.

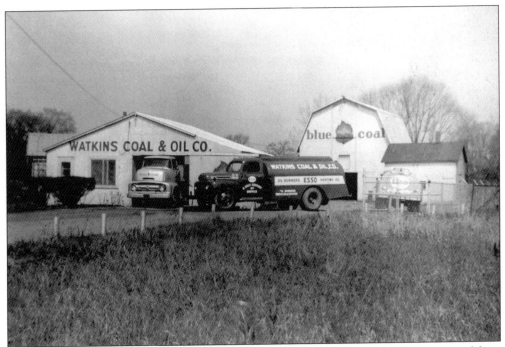

Most communities still have their oil companies, but coal, which pretty much disappeared from the home-use scene for a while, is making a comeback.

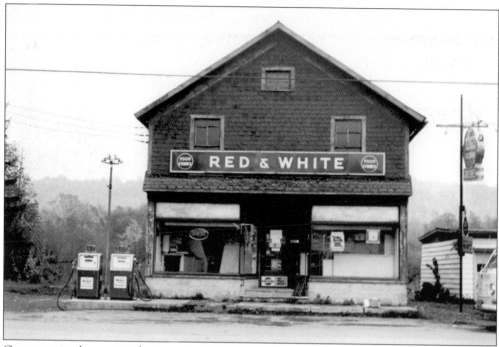

Gas, groceries, beer—it is the same concept as today's convenience store. The question is why did places like the Williams Country Grocery in Beaver Dams seem like so much more fun to visit?

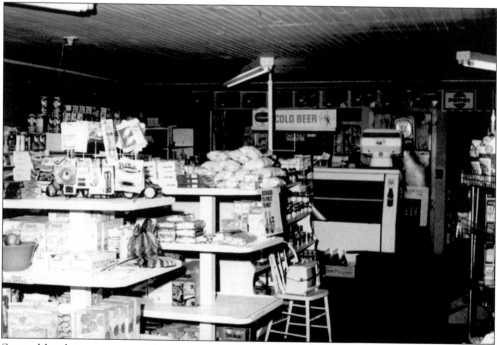

Stores like this were an overflowing paradise for small children, and they were friendly places to boot.

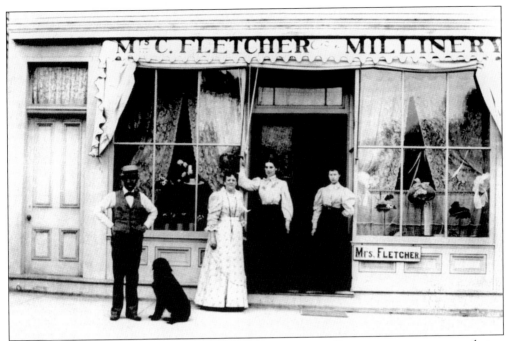

Milliners, now long forgotten, were once common even in small towns, as everyone wore hats.

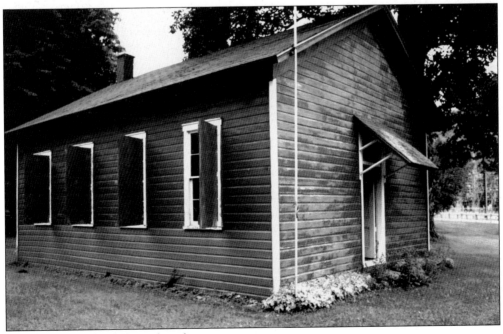

The 1884 Lee School House later became a museum.

This has been a great trip through Schuyler, but fill up the tanks. There is always plenty more to see.